MY HEART ROCKS

"A gorgeous gem of a book, each page a treasure brimming with beauty, magic and inspiration. Amy's photos also feel like a generous invitation to find our own heart-shaped rocks, to slow down and look for what's possible and available, that if we focus on seeing love, we might find it all around us." —Lisa Genova, author of *New York Times* best-selling novels, *Still Alice, Left Neglected, Love Anthony,* and *Inside the O'Briens*

"Without question, Amy Dykens is one of New England's finest photographers, and she has taken her art to even a higher level with *My Heart Rocks*. Amy's book Rocks! It rocks with creative vision to a place of the soul: heart stones shaped by the sea; 'the universal symbol of love, carved through time' she observes. Love takes time, and it is shaped by many forces—some gentle, some fierce. Amy teaches us that if one is willing to search in all seasons, one can find peace and beauty in life defined in extraordinary ways." —Greg O'Brien, author of *On Pluto: Inside the Mind of Alzheimer's, O'Briens Original Guide to Cape Cod and the Islands: A Guide to Nature on Cape Cod and the Islands*

"In nature, as in people, we are all perfectly imperfect. In *My Heart Rocks,* Amy Dykens shows us the wonder, life, and beauty that surrounds—and unites—all of us." —Timothy Shriver, Chairman of Special Olympics, and author of *Fully Alive: Discovering What Matters Most*

AMY M DYKENS

MY HEART ROCKS

4880 Lower Valley Road · Atglen, PA 19310

Copyright © 2016 by Amy M Dykens

Library of Congress Control Number: 2015954530

Designed by Brenda McCallum
Type set in Cinzel/Agenda

ISBN: 978-0-7643-5063-4
Printed in China

Published by Schiffer Publishing, Ltd.
4880 Lower Valley Road | Atglen, PA 19310
Phone: (610) 593-1777; Fax: (610) 593-2002
E-mail: Info@schifferbooks.com

For our complete selection of fine books on this and related subjects, please visit our website at www. schifferbooks.com. You may also write for a free catalog.

This book may be purchased from the publisher. Please try your bookstore first.

We are always looking for people to write books on new and related subjects. If you have an idea for a book, please contact us at proposals@schifferbooks.com.

Schiffer Publishing's titles are available at special discounts for bulk purchases for sales promotions or premiums. Special editions, including personalized covers, corporate imprints, and excerpts can be created in large quantities for special needs. For more information, contact the publisher.

Other Schiffer Books on Related Subjects:
Cape Cod Perspectives, Douglas Congdon-Martin, 978-0-7643-2766-7

FOR CHARLIE AND JAMES WITH LOVE.

"All of us have in our veins the exact same percentage of salt in our blood that exists in the ocean, and, therefore, we have salt in our blood, in our sweat, in our tears. We are tied to the ocean. And when we go back to the sea—whether it is to sail or to watch it—we are going back from whence we came."

—John F. Kennedy

INTRODUCTION

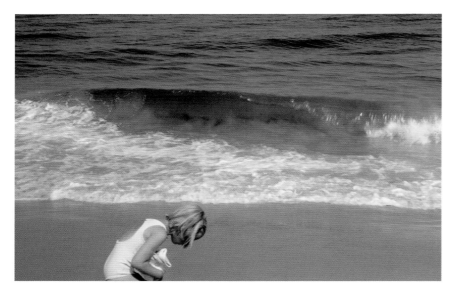

Amy beachcombing at age five, photo by her dad.

What a delight it is when I meet a fellow beachcombing rock-hound, both members in our secret society—I intuitively understand our shared joys and instantly know "this is a person I like." I am always tickled when people ask about my finding and photographing rocks, and then how most folks respond with a story about an outstanding beach stone from their past, usually including a detailed description, their relished recollections manifest in their voices. I have heard countless stories about a lucky stone carried around for years in a pocket, many heart stones discovered and then given as valued gifts, and of course, the best places to look for such precious stones. Imagine how touched I was when, while going through my beloved father's office after his death, I found some small bags of beach stones, collected in his travels and carefully cataloged by location. There is a trite, somewhat tongue-in-cheek "law of genetics" that "the apple doesn't fall far from the tree," and I guess I'm a proof of its validity.

We all love the beach; we go there for the beauty, the roaring of storm waves as well as the soothing of calm seas, the fresh air, the simple joy of sand between our toes. My walks—my daily moving meditations—are what started me on the journey resulting in this

book. As an overextended wedding photographer and single mom, I would do whatever I could to fit in my daily beach visit, my stress reliever, and my source of peace and place. The more I walked, the more essential it became.

I have always been captivated by beach stones, shaped and deposited by the sea, and on these walks, heart stones rose like cream to the top. Heart stones are nature's loving gift, the universal symbol of love, carved through time by their environment, a joyous discovery to find and hold in one's palm. The ancient Greeks believed that the heart was the seat of memory, hence our phrase "know it by heart." But in addition to preserving memory, heart stones can convey peace and love, and best of all, can be shared; one of my good friends uses them to encourage and reassure children in her therapy practice.

They can also be photographed! Once I started creating images of these gifts from the sea, it became my passion.

As soon as I get over my initial excitement of finding a heart, I immediately start to imagine where and how to best capture its beauty and uniqueness. In most cases, the photographs are taken in the exact location where the rock was found, and because my wedding business is somewhat seasonal,

many of the images were captured in the very cold winter months, in my wetsuit or waders, hands frozen to the camera. Some of them are taken on dry sand, some in the surf, and others underwater. The unpredictability of the water, the waves, the wind, and the light, makes shooting the images both exciting and challenging—I am always aiming for the image that best conveys to me the special character of a given rock. I love editing the images; because the water is in constant motion, it is always a delightful surprise to see how each ephemeral splash, wave and bubble was caught in mid-stride.

Many of my dear friends and loving family have helped me search beaches in a shared quest for heart stones. These are among my happiest hours. I remember finding every single one—you could rightly say I know them all by heart. Some of these stones were generously gifted to me, and I cherish every one. The making of this book and these images has also enabled me to visit many locations for beachcombing and photography, a dream come true giving even more purpose to my dedication and journey as a photographer.

My daily walks bring me peace, joy, and discovery. Whatever you seek in your beach walk, rock on!

"Heart stones are nature's loving gift, the universal symbol of love,
carved through time by their environment, a joyous discovery to find and hold in one's palm."

Child Bearing

This, my first heart rock image, was a magical moment. At the end of a summer's day on one of my favorite Nova Scotia beaches, the light was stunning and the water extremely still. On this gorgeous evening, I was wishing for a subject to take, when I remembered the two heart rocks that I had found on my walk earlier in the day. . . . Little did I know that I was about to embark on a meditative journey of discovery, healing, photography, travel, and devotion.

Heartfelt

My theory of rock-hounding is that the rock finds you when you need it most. This seems especially true of heart rocks. This gleaming white beauty came to me on a walk at the end of a difficult day. The odds were against me: It was high tide and almost dark. Then, lo and behold, this exquisite rock was waiting for me. I knew instantly the type of photo it deserved—peaceful and serene, just like it made me feel when it found me.

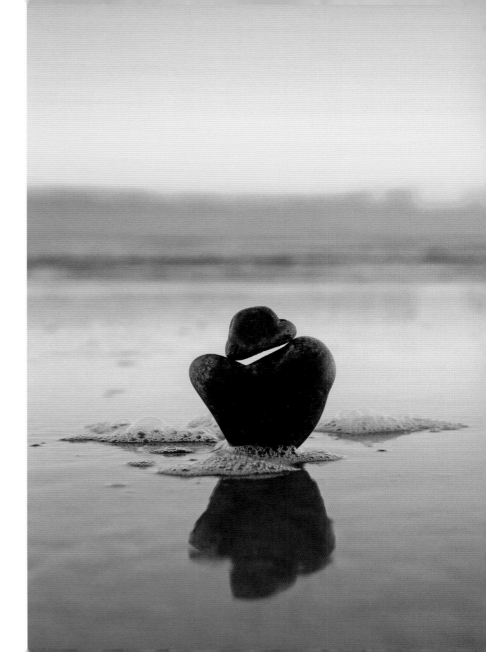

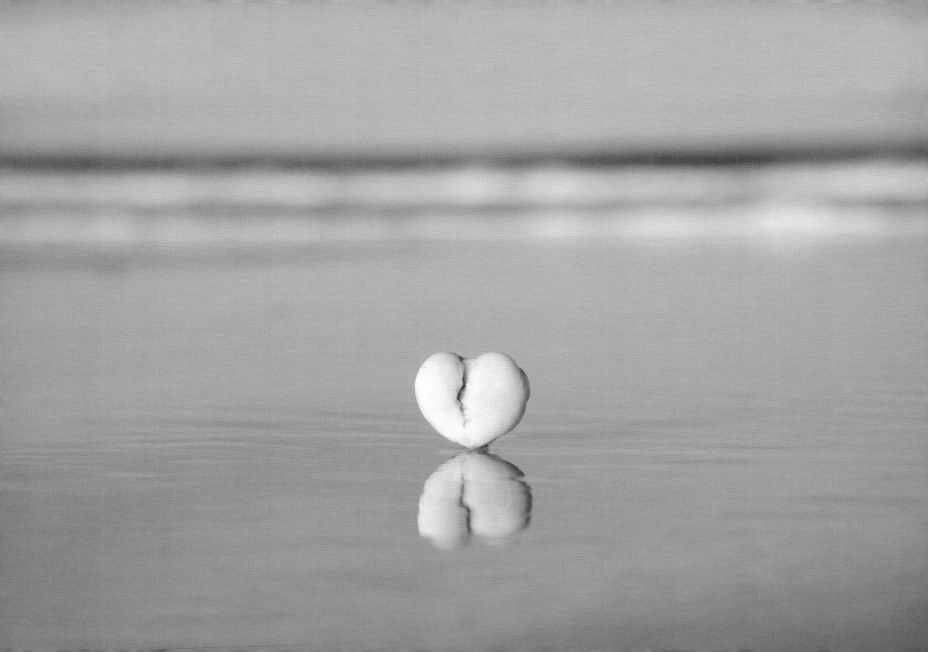

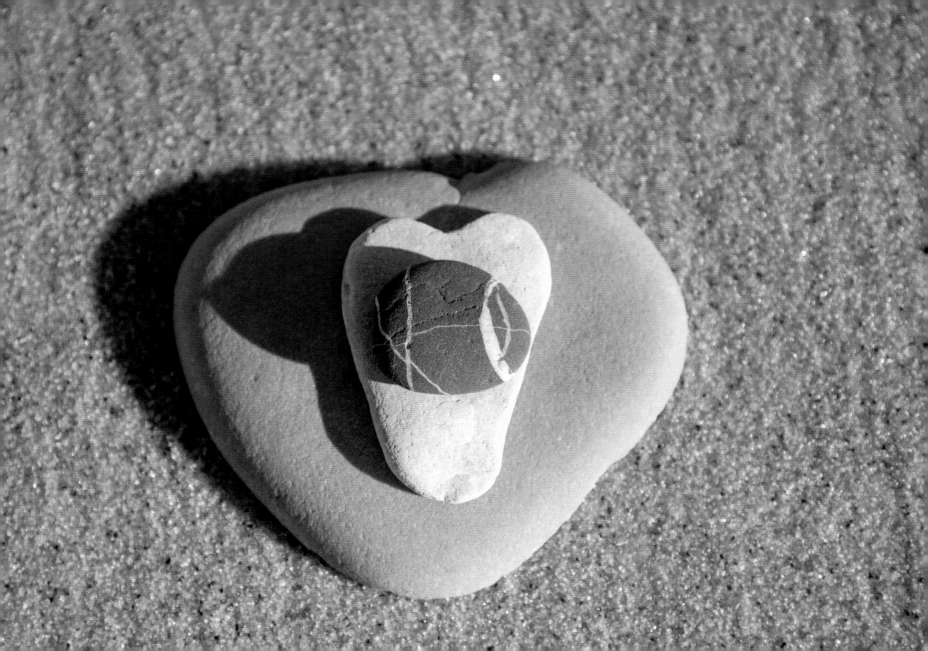

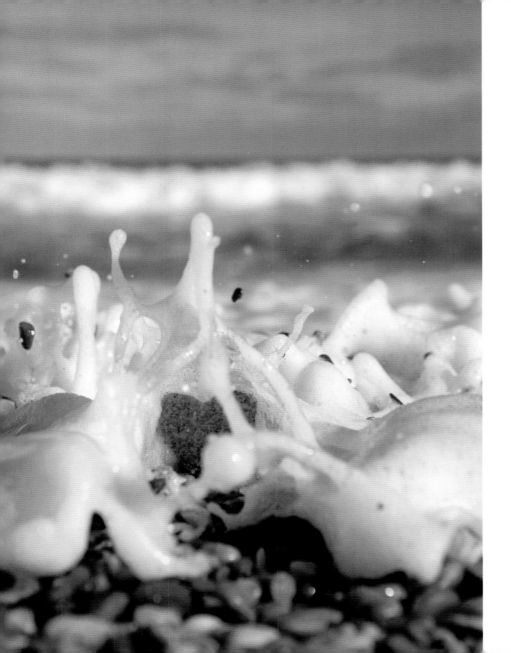

XO

Being a hopeless romantic, I find it pretty exciting to discover stones with Xs and Os. On rare occasions, I find stones with both an X and an O, which are deservedly cherished.

Rock Tumbler

Mother Nature caught in the act, tumbling these pebbles into smooth treasures while also shaping a heart

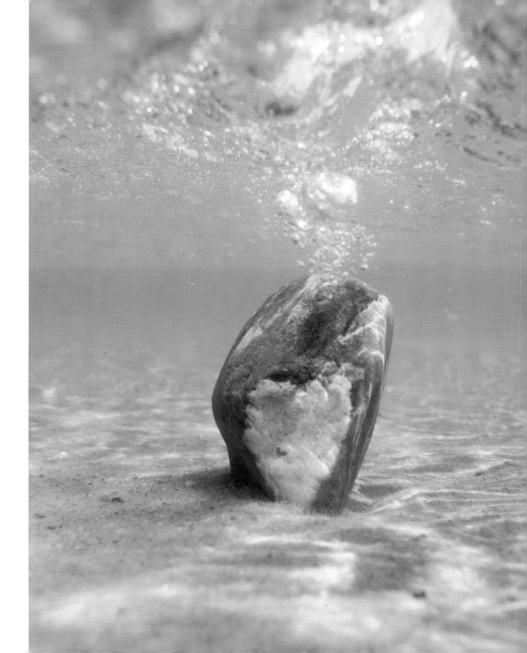

Together

Heart rocks come in all shapes and sizes. Here we see two hearts on the same stone—a white heart on a dark stone and a tiny, dark heart on its white host. What a serendipitous discovery!

Lighthearted

It was a delight when I noticed that the space and light travelling through this stone was heart-shaped, making the rock open and light, not solid or heavy like so many of my other heart rocks. Even though I had been photographing beautiful heart rocks for over a year, I was mindful of the way the incoming azure waves are framed through this rock, pure and simple.

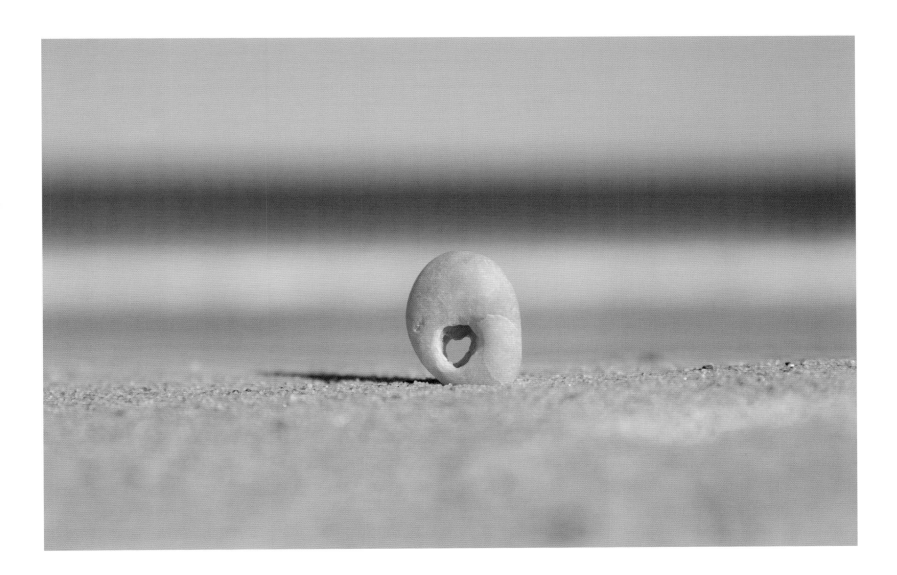

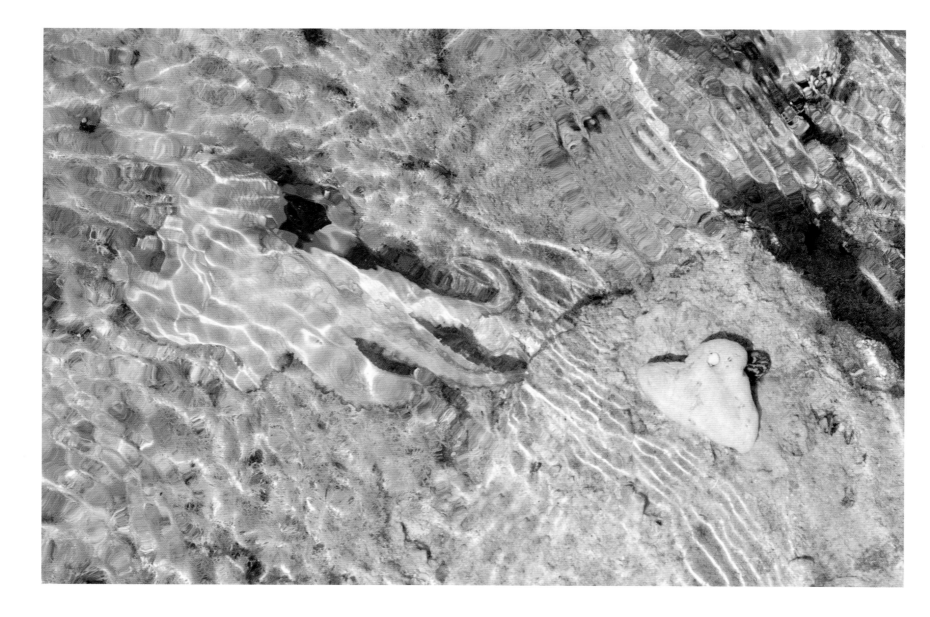

Baby Octopus

While exploring a reef from above, I spotted an octopus curled up and camouflaged amongst its surroundings. I slowly lowered my heart rock into the water, thinking that there was little chance that my octopus friend would still be there when I could stand up and look through my lens. The octopus launched itself in a split second, but that split second (actually 1/1000th of a second) was all that I needed to catch it darting away. I love the how the octopus looks under the agitated water and dancing light, and also the shape of the heart rock, which even appears to have its own eye.

Closing In

The ocean is hugging this unique heart found on Cape Cod, simultaneously revealing the very forces responsible for its genesis.

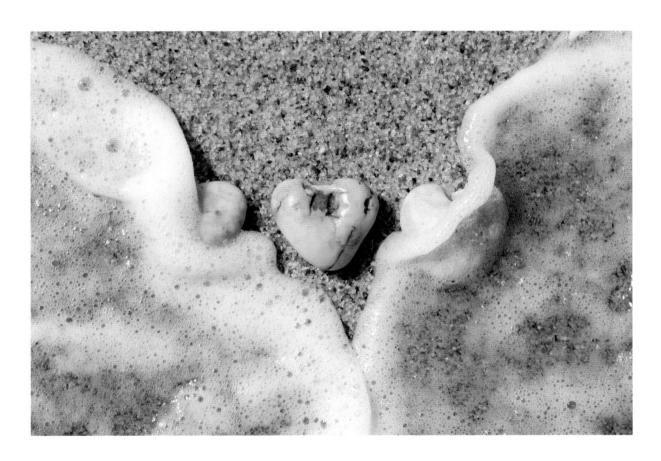

Treasure Island

When I first saw this beautiful rock that found my friend in Chatham, I knew exactly how I wanted to photograph it: a little treasure on a tiny island.

Nauset Mermaid

An interface image with lens half beneath and half above the water. When I photograph stones underwater, I typically lie face down and kick with my legs so that the motion in the water catches interesting light in the image. One day in early April, a woman came out of the surf and asked what I was doing (it does look a little strange). We chatted briefly and, as I captured her walking away, the image became a privately meaningful metaphor of a woman walking away from a heart of stone.

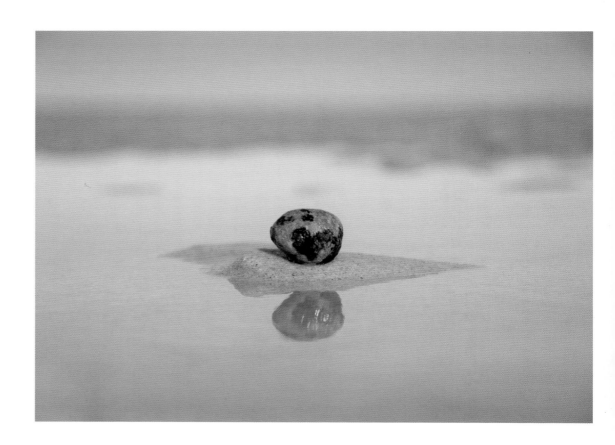

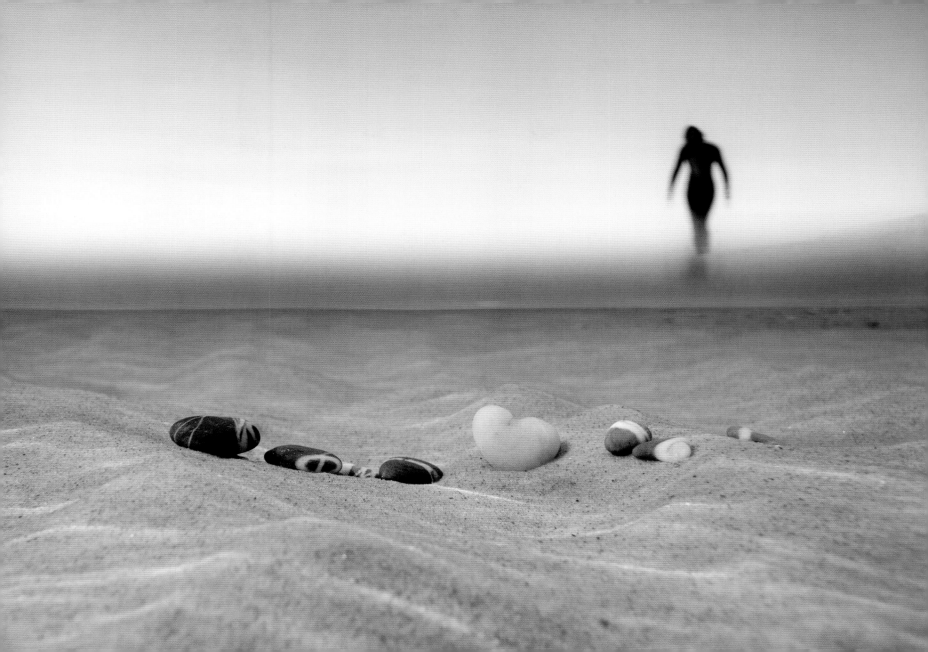

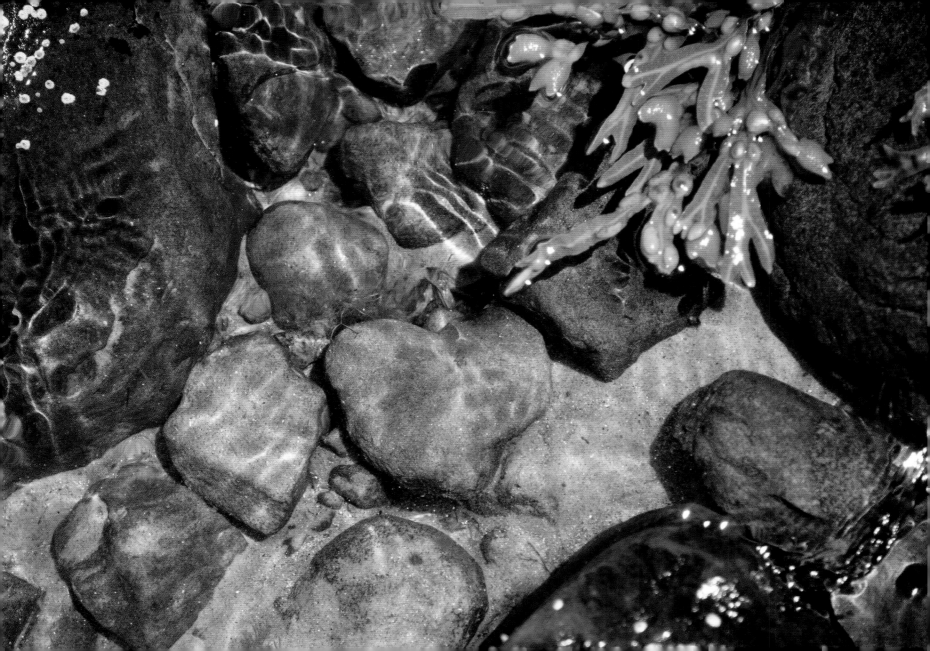

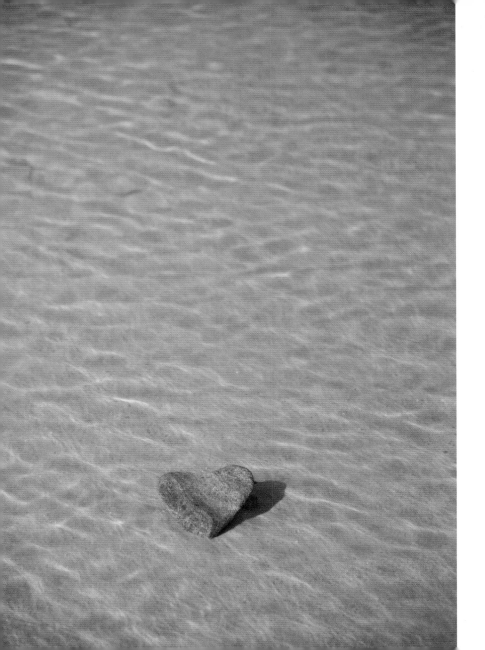

Mouth of the Sable River

On this day, my internal monologue went something like this . . . "I really would like to find a heart rock right here at the mouth of the river, one that looks like it has been here forever and belongs amongst the rockweed oh wow, here it is!" That's my theory at work again, when you need a rock reminder to prompt contemplation, they find you. Every day while in Nova Scotia I go to this stunning place at the end of Louis Head Beach and the start of the Sable River, Shelburne County. It is one of the most beautiful, memorable places in the province—the water clear, the sand soft, the rocks diverse in their beauty and the currents as wild as the woods, and all punctuated by the small islands off the beach. I remember finding every single heart rock, but this one especially.

Carter's Island Nova Scotia

This heart rock sits in perfectly clear water as far as the eye can see—Caribbean clear, yet arctic cold.

Nova Scotia Blues

Carter's Island Nova Scotia has the most stunning clear blue water imaginable—if you didn't know you were in Canada, you would swear that you were in the Caribbean. I was enthralled with the layers of color, the white sand and the blues and greens of the water and sky. This symmetrical black heart rock from this very beach was also the perfect choice to underscore and celebrate such a gorgeous beach palette.

Among Friends

When we lie in a prone position at the beach, tired from swimming and flopped on our towels with our faces to one side or another, we look out across the sand at a crab's eye view, a very low angle. An uncommon position for most of us (having your ear planted on the ground), I have come to love this angle to view and photograph the world. When photographing my rocks, I am often looking across the sand at the lowest angle possible, from the viewpoint of the rock. When you get down really low on a beach, a sprinkling of pebbles appears like a rainstorm. This day at Nauset Beach, the pebbles struck me as particularly colorful and a great backdrop for this extraordinary heart, perfectly shaped, a warm chestnut color when wet and wrapped with two dark lines like strings holding it together.

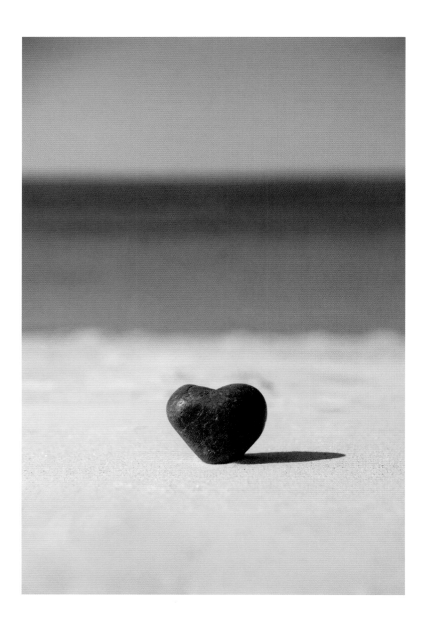

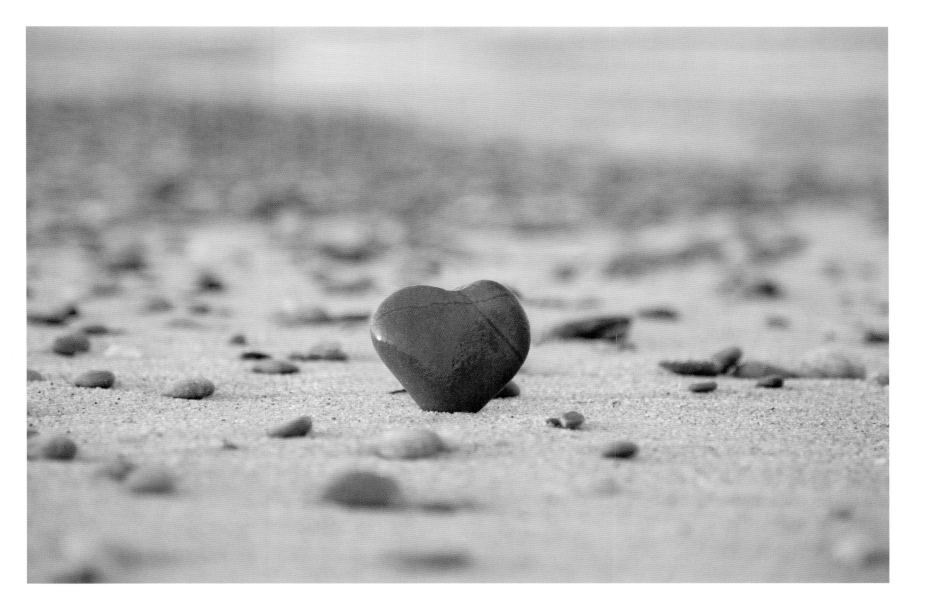

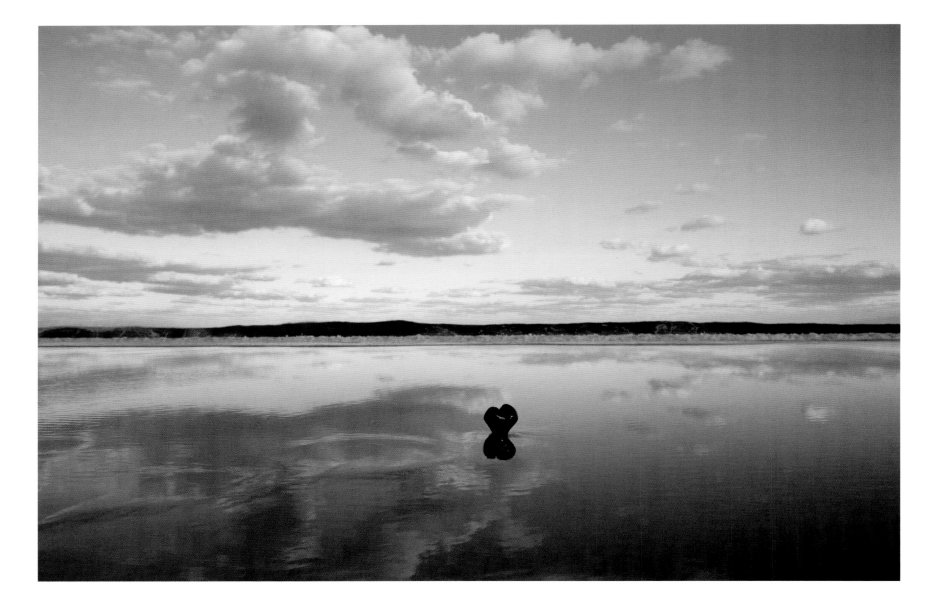

Nauset Reflection

My love for Nauset Beach runs very deep. Although many aspects of this beach have captivated me for a very long time, I am most intrigued by how much the beach changes. I am there nearly every day, scrutinizing the location of the sand, the tidal pools, the shape of the beach, the waves, the water, and the stones. When I leave the beach, my ritual is to stand at the top of the path for one last look in each direction, committing it to memory. Returning the next day at the same tidal level, I am often astonished that the beach does not resemble the prior day at all. Sometimes the wet sand is as smooth as a mirror and captures the sky's reflection.

Sun Bay Fish Play

Upon seeing these beautiful fish in a tidal pool at Sun Bay, I wondered how I could possibly get them to come over to my heart rock, the first I had found in Puerto Rico. My secret strategy is patience. Eventually the fish came over to investigate, and I was able to capture one in mid-sniff. I enjoy taking photos partially underwater, capturing the setting above water, providing a sense of place, while the reflective shimmering surface of the water provides a sense of peace. It is special to be part of the secret place below, despite being limited to visitor status.

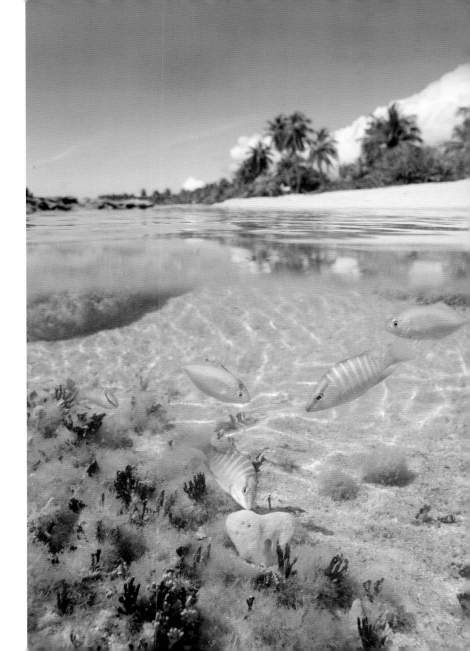

Sweethearts

As kids, spending time at the beach meant playing "beach bakery." We would make sand cakes and sand ice cream and take turns being the baker or the customer. Light sand for vanilla, dark for chocolate, and dry fine surface sand replacing the confectioner's sugar sprinkled on top, with colorful pebbles as decorations. These are very happy memories—sometimes when I look at the vibrant, colored stones on the beach, I am reminded of how we could make almost anything we found into a yummy confection. And best of all, calorie free!

Nauset Lace

I love it when an incoming tide over a flat sandbar finds the waves slowly travelling across the sand like billowing lace.

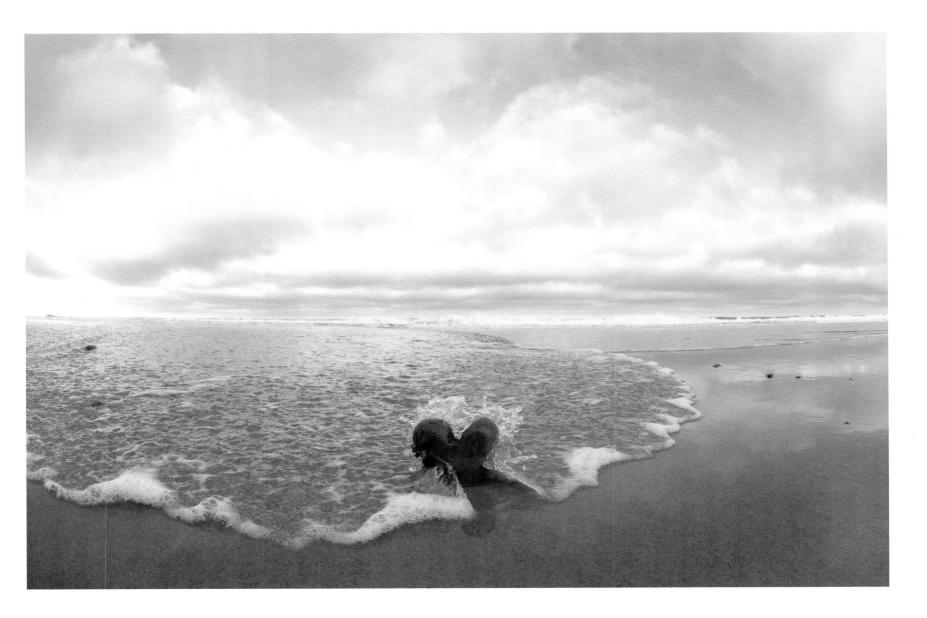

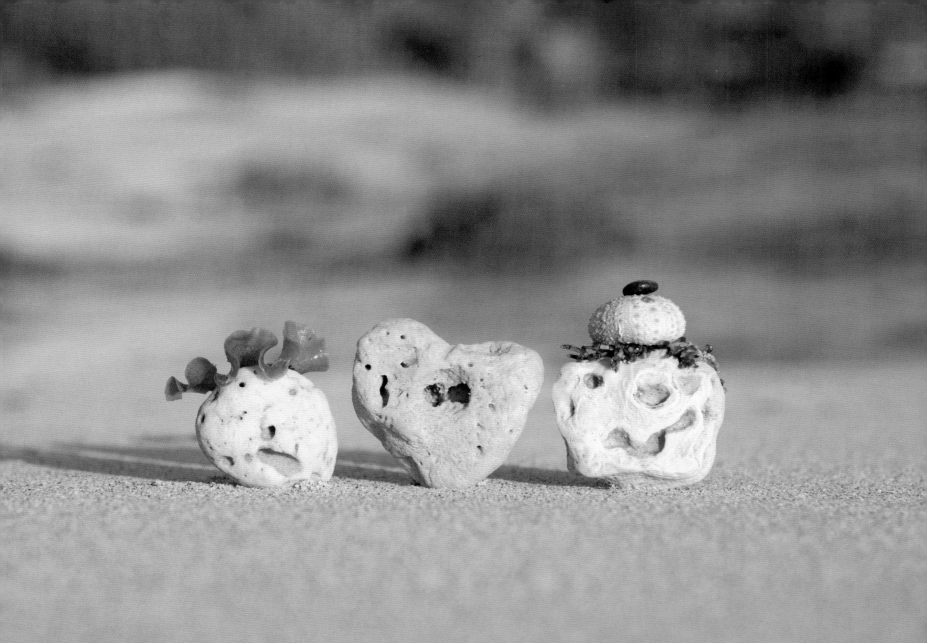

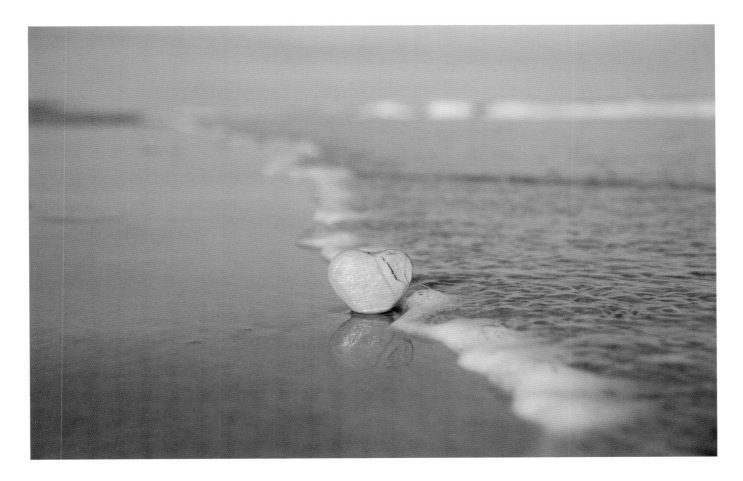

Rock Face

Sometimes when quietly browsing the beach, faces jump out to me. Grumpy or angry or happy, they all make me laugh. These two were buddies from the start, like two jack-o'-lanterns, found near each other in Puerto Rico.

Imperfect Perfection

A missing atrial piece, but still perfectly clear in its intentions with its reflection and surrounding gentle lacy wavelet, this one found me at Nauset Beach.

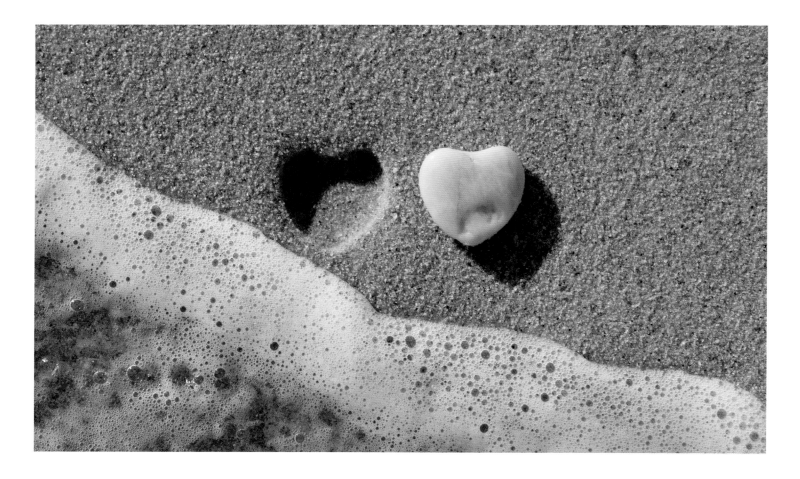

First Impression

Despite its slight surface irregularity, this heart has a lovely uniform shape, reminding me of something mass-produced, as if from a cookie cutter or a stamp. I started using this natural wonder to make impressions in the wet sand—the shape pressed into the sand as beautiful as the stone itself —the former soon erased, the latter destined to endure.

Love Letters

Today I wrote four letters...
L, O, V, and E.

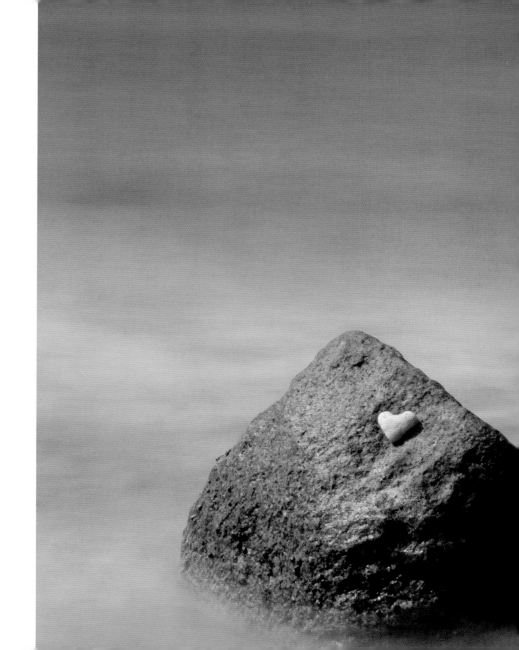

Coconut

This beach in Vieques took my breath away. The aqua water, the whirling water around the rocks, the tropically towering clouds, and the gentle sway of trees all conspired to inspire, yet simultaneously, comfort. This pristine diminutive white heart was found just feet from where I chose to photograph it—on a day I will remember forever.

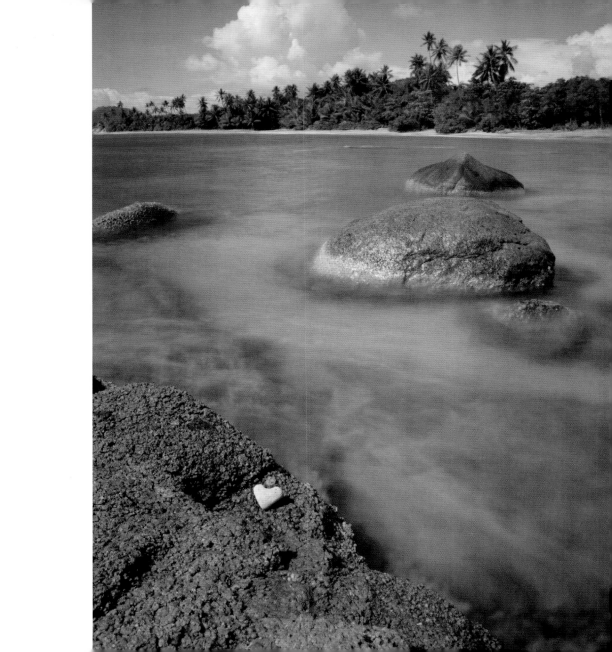

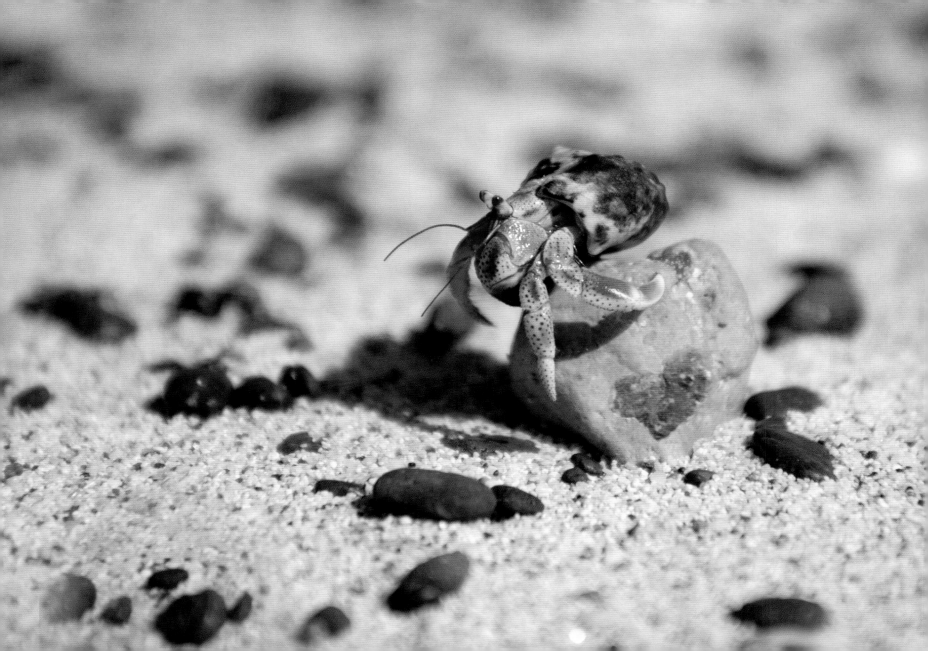

Pink Polka Dots

As far back as my memory goes, I recall how much my beloved sister and I have loved the color pink. We had pink flowered wallpaper, pink bedspreads and, as adults, our homes definitely host a fair amount of pink. Now imagine our smiles when we happened upon a beach with hot-pink, polka-dotted rocks in abundance! These coral-sprinkled rocks delighted us, and we found several with splendid pink heart shapes. Kudos to the hermit crab for adding a flash of orange, providing a bright contrast.

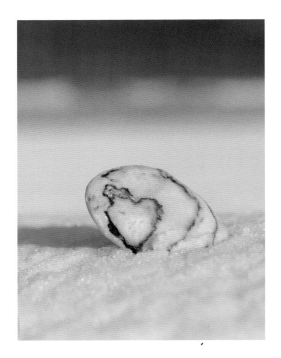

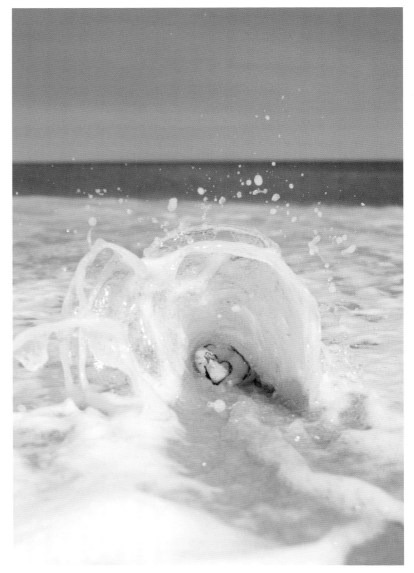

Christmas Gift

It was a sunny and clear New England Christmas day, and I was not alone on the beach, as I often am on my winter walks. This stone was tossing in the waves, and I only had a quick glance at what appeared to be a black ring around a white rock. It was intriguing enough that I ran out when the wave receded and fetched it. Returning to the dry beach and turning it over, I realized it was pure delight—a gift from the sea. I photographed this Christmas rock in the snow and surf in the area of Nauset Beach where it found me.

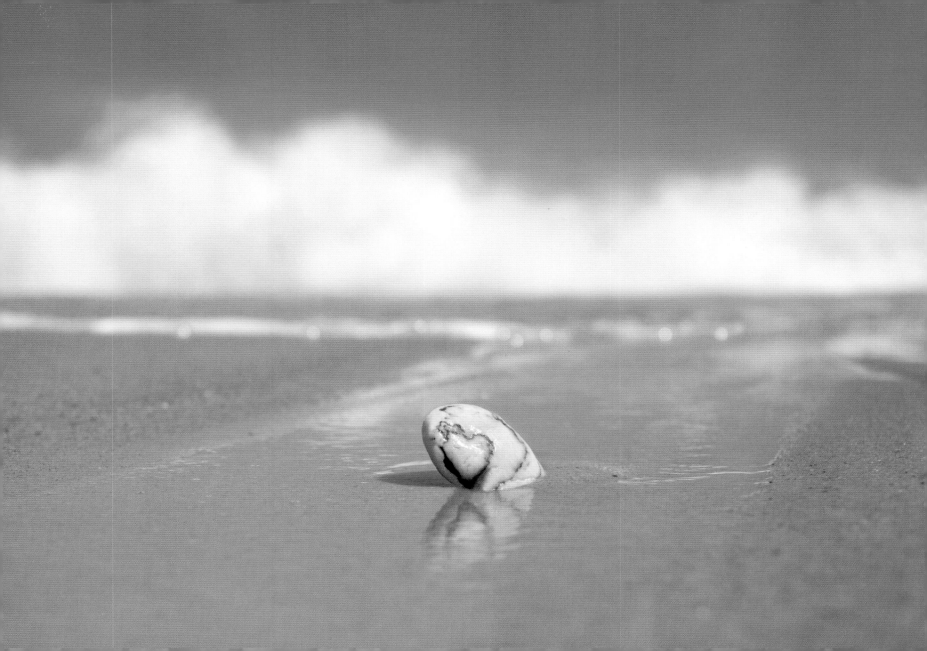

Twinkle Lights

This partially underwater image from Pleasant Bay in Orleans, Cape Cod, captures how beautifully the water surrounding this heart catches the light in surprising ways— twinkle lights in a summer's garden.

Green Heart

On an unforgettable hike in Puerto Rico with my beloved sister, I spotted this absolutely perfectly shaped heart carved into a brilliant green rock. We thought for sure that we could move it from its spot to examine and photograph it, but it was much too big and very happily situated in the crashing surf. I loved being able to capture this beautiful heart just before it got another soaking by the waves from which it was made.

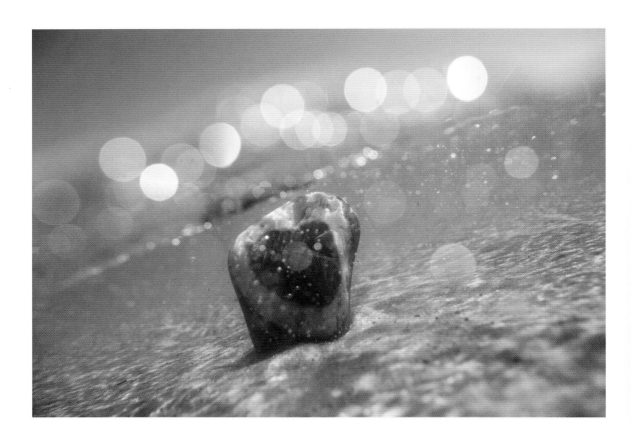

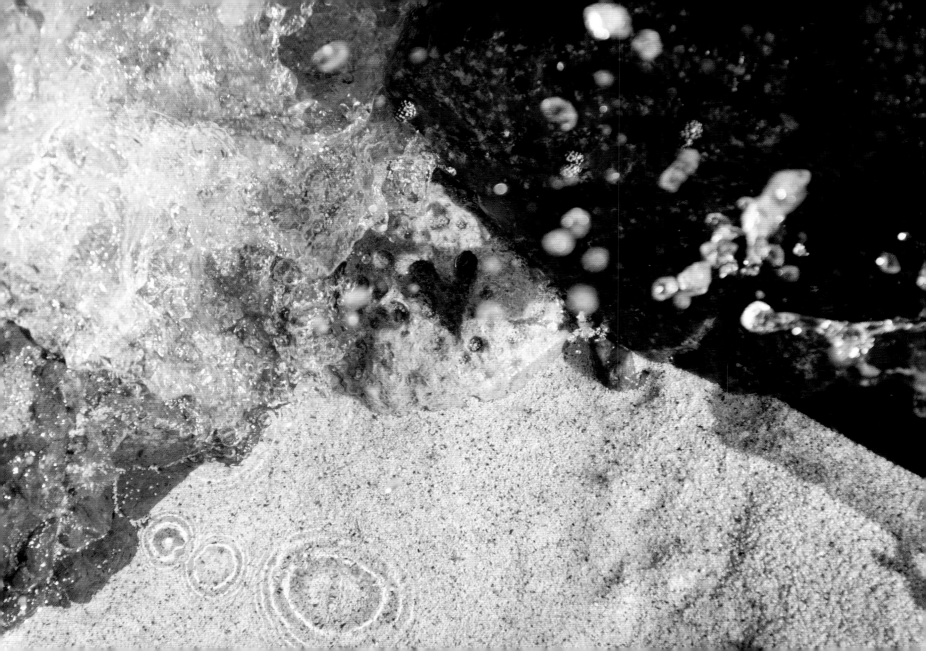

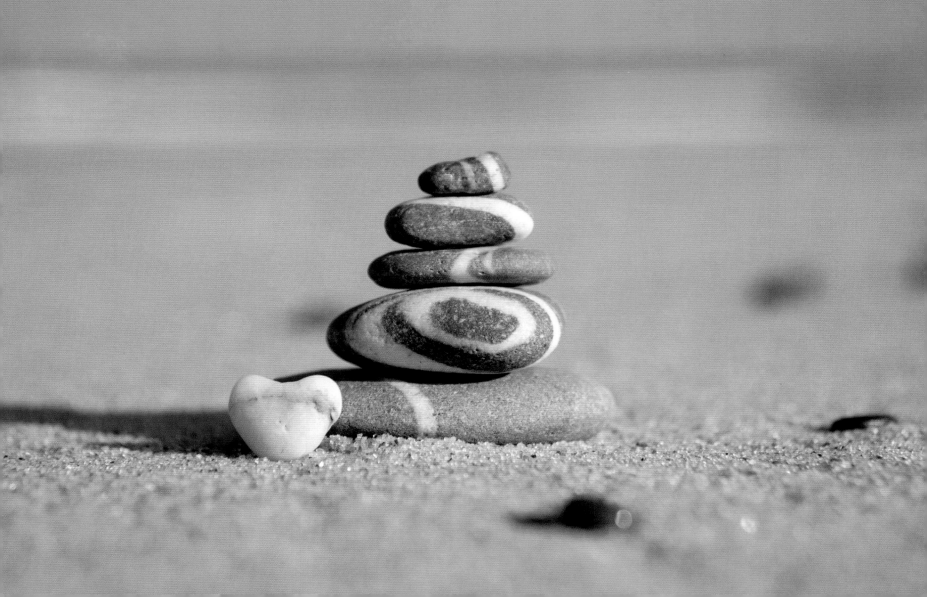

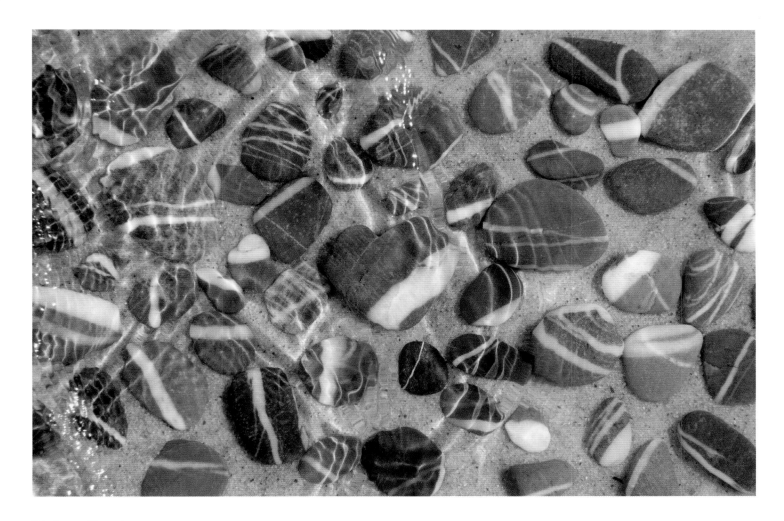

Zebra Rocks

I have been bending over for lucky stripes from the time I could stand up. The fascination
has not waned one single bit and finding these stones remains a delight.

Opposites Attract

These two reciprocal knockouts found me in Nova Scotia awaiting this gentle, light-filled wave. A couple worthy of a sigh and pause for contemplation.

Ace of Hearts

Standing in about a foot of wildly swirling, warm Caribbean water, I spotted what appeared to be a dark heart at my feet. Retrieving revealed another delightful surprise—a rather worn, irregularly shaped rock with a perfect heart indentation. In certain light, the heart was hard to discern, but when held just right, it jumped out like a heart on a playing card. I knew that it had to be photographed in a similar place so when I spotted this subtle mermaid's hair swaying to and fro, I knew just which heart rock belonged there.

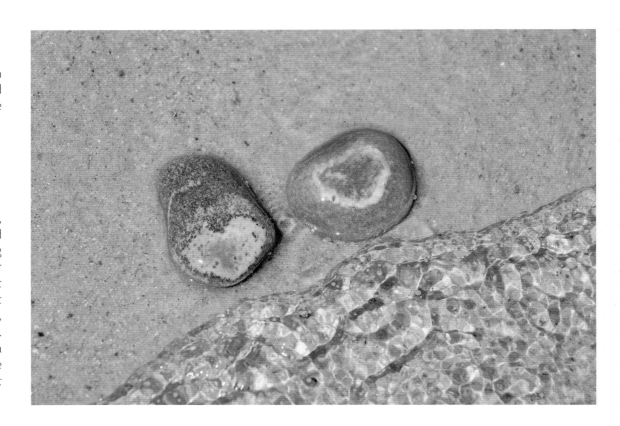

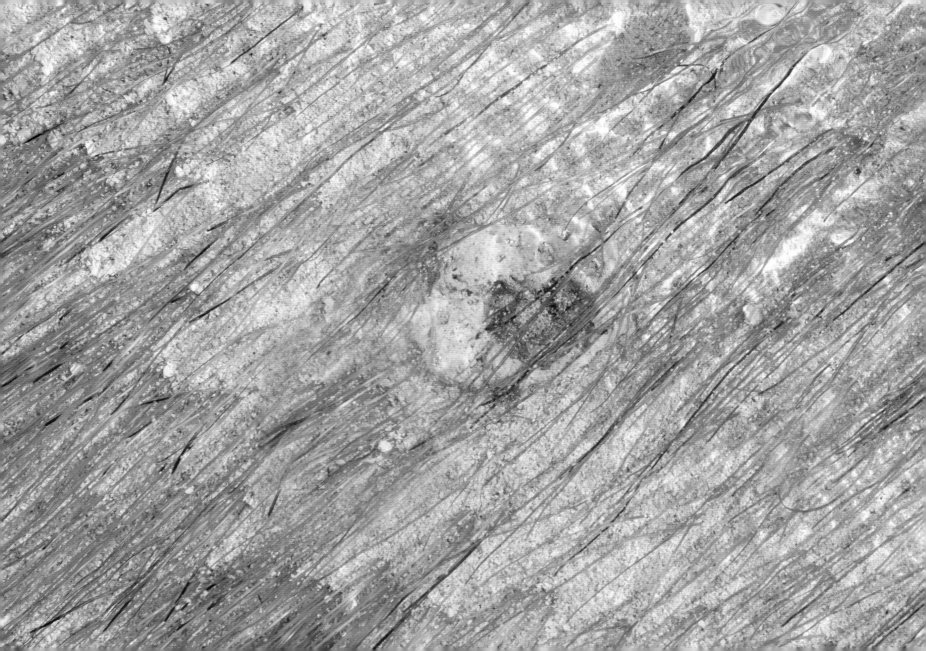

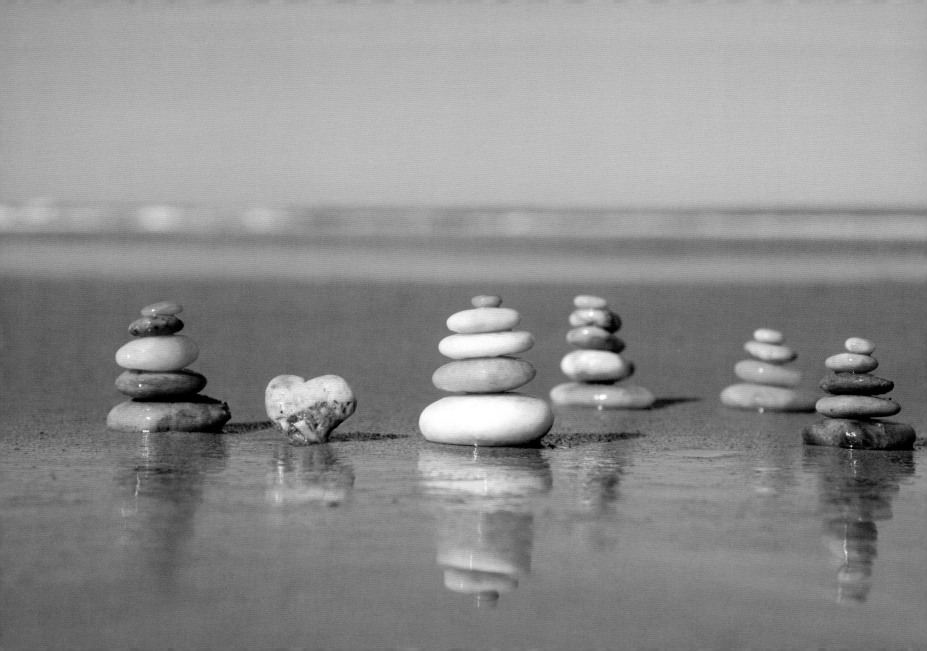

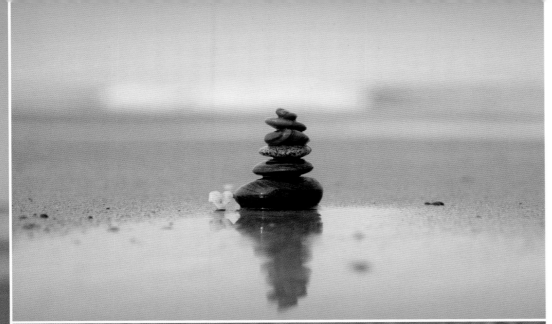

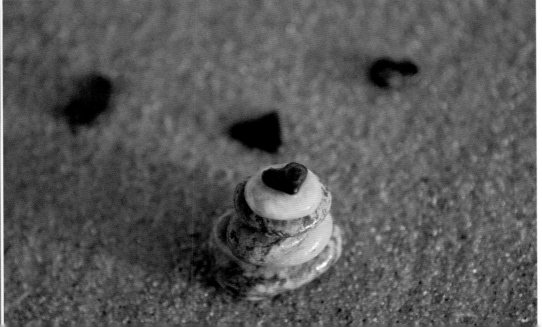

Vivid Cairns

Not exactly Stonehenge, but these bright and vibrant cairns, composed of precious gems that found me, and as ephemeral as the tides, still bring me a sense of balance and joy.

Heartfelt

Certain images bring forth happy memories, this one in particular. On this early evening, my assistant and chief rock handler was my son, Charlie. We had a fantastic time taking this one—many waves, many times stacking the stones, and many laughs. Thanks and love to both of my guys for indulging your mom.

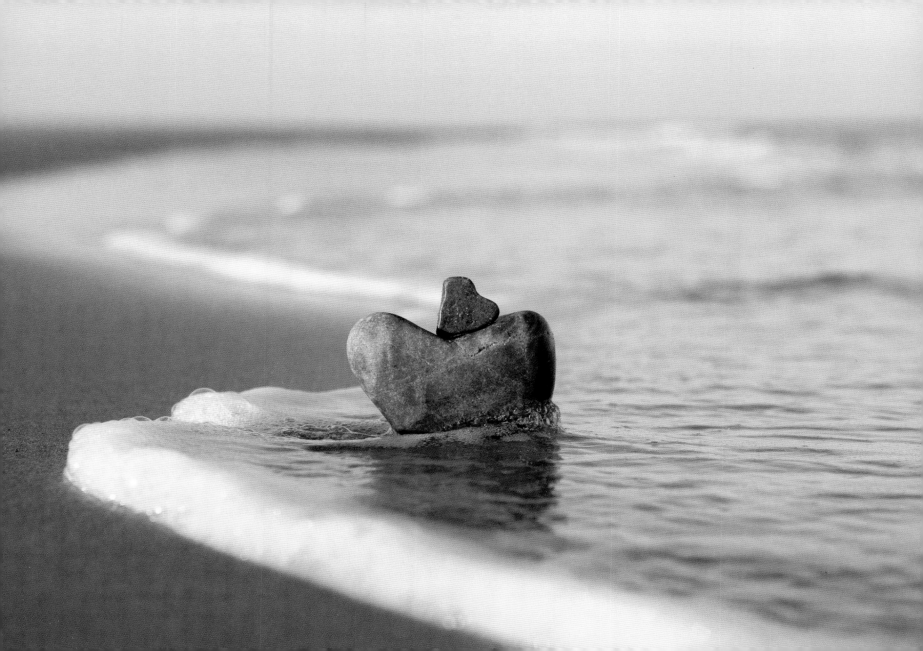

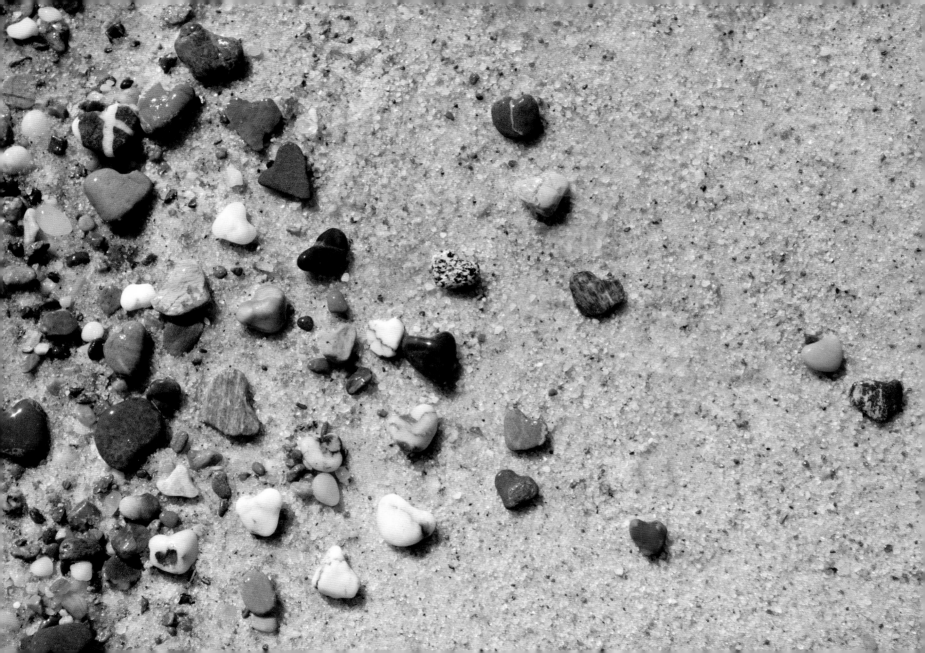

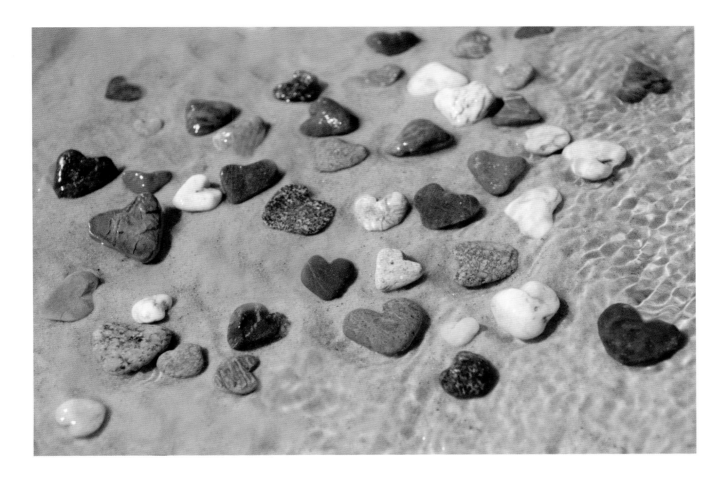

The Joy of Discovery

Walking the beach is a peaceful meditation that I look forward to every day. There are many parts to a daily beach walk: the tide, the wind, the surf, the temperature, and (of course) the gifts from the sea that lay in wait on the strewn beach. Sometimes the stones are sparse, only a few here and there bringing a pleasant anticipation to the rockhound. Other times, an endless assortment of stones seems to be everywhere, both overwhelming and exciting.

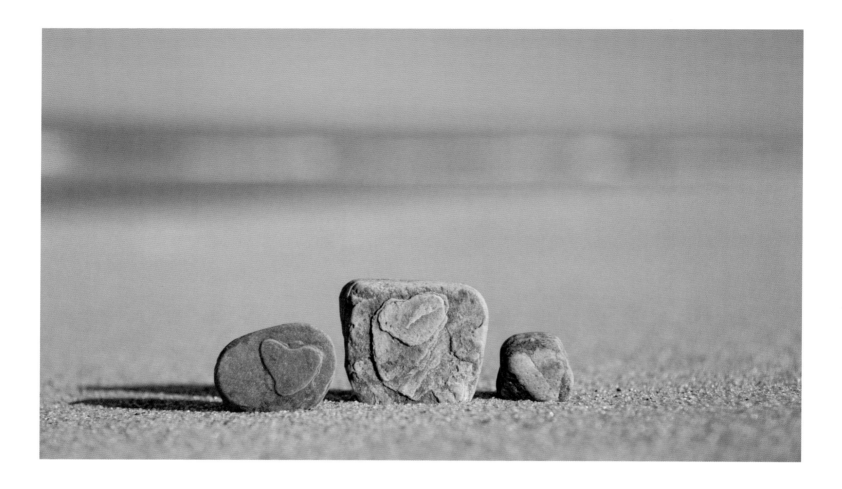

Headstones

Heart rocks come in all shapes, sizes, and colors. Some of my favorites, the most rewarding and wonderful to photograph, have hearts that are subtle in texture and color.

Cape Cod Baydreaming

Red sky at night, sailor's delight.

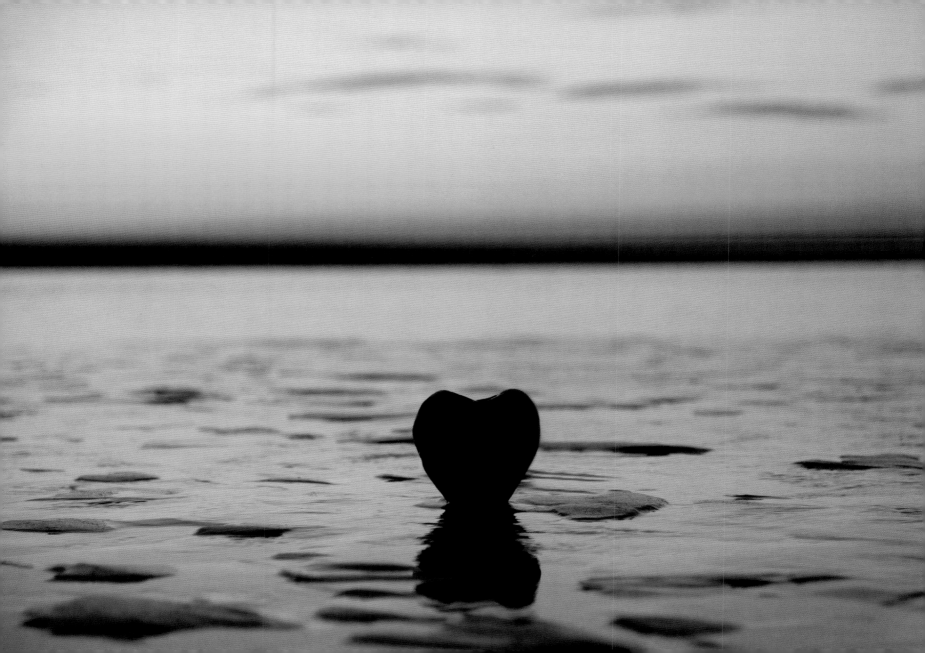

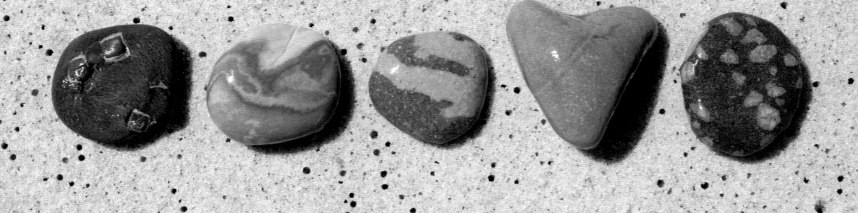

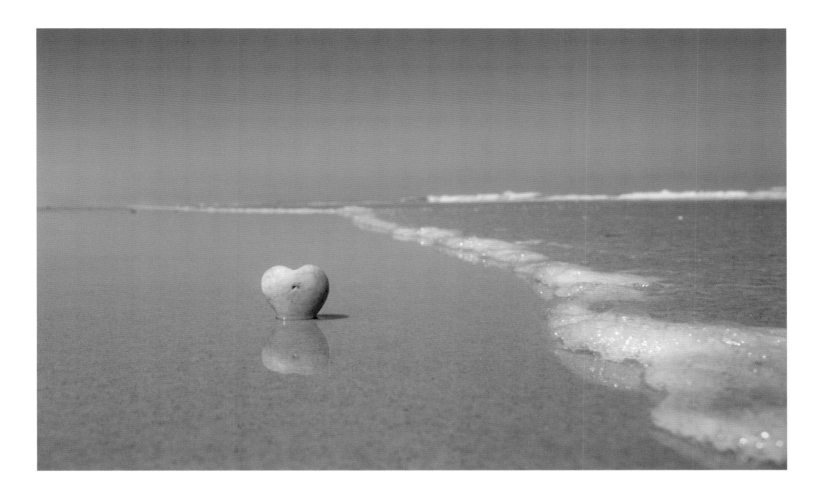

Solar System

When beach rock-hounding, I often ponder which familiar object a given stone reminds me of. When I put this grouping together against the speckled sand, they seemed simply celestial.

Heart Standing Still

Serenity at an empty Cape Cod Beach, water so still the reflection is perfect, the sky a blank blue canvas awaiting imagination.

Brief Encounter

This moment of stone and foam was fleeting and surprising. The stone, which has existed on earth for countless years, and the foam, which appeared and left within seconds, made for a lovely encounter illuminated by the water's constant motion and variety.

Catching Waves

Surfers and photographers wait to catch the right wave, both attuned to the rhythm of the sea.

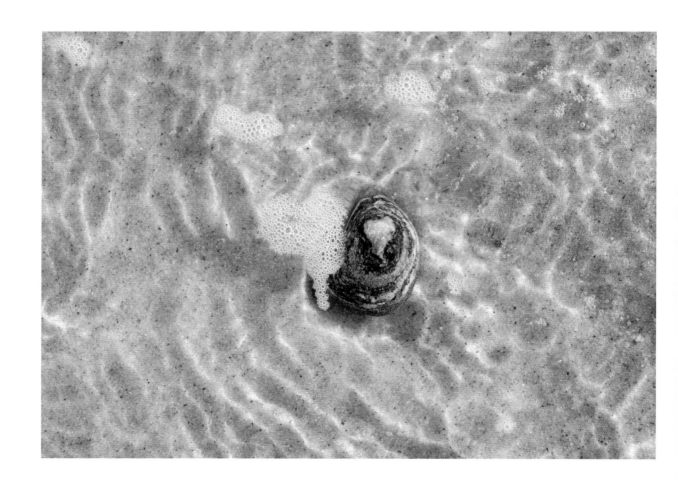

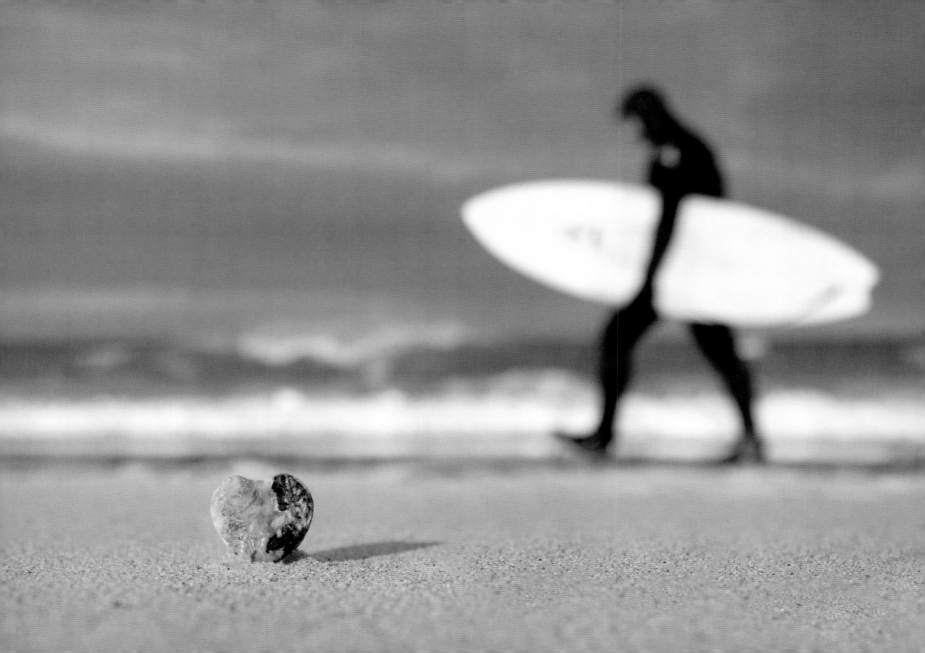

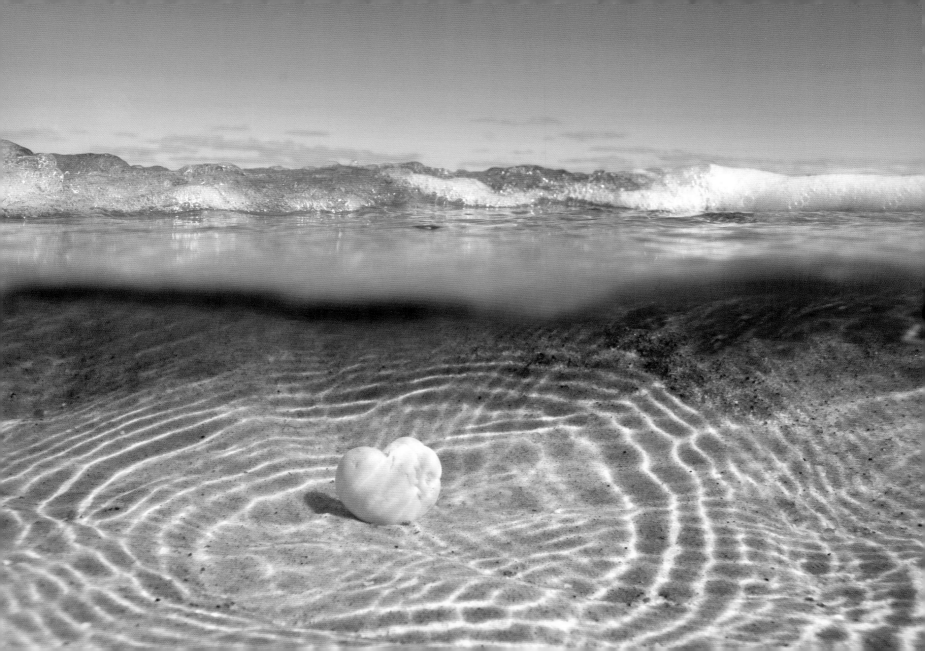

Inbound

Whether waves are incoming or outgoing, with varying sizes and sounds and changing colors (even in a single wave), we are drawn to the sea to watch and hear the waves. I love to be in the waves trying to capture the dynamics of all this. One of my favorite things is to be underwater in a tidal pool watching the waves approach at eye level, the surface foam leading the charge while down below, the impending end of the short-lived peace before the wave arrives yielding refractory turbulence and shadows, plus the requisite rolling sand storms.

Stone Washed

A red heart painted on a smooth gray canvas, glistening from a recent wave. I pause to ponder how geology can yield such intimate contrasts, like a decal.

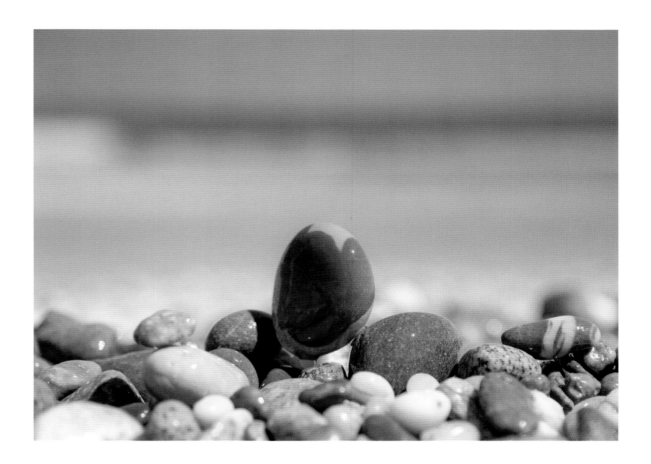

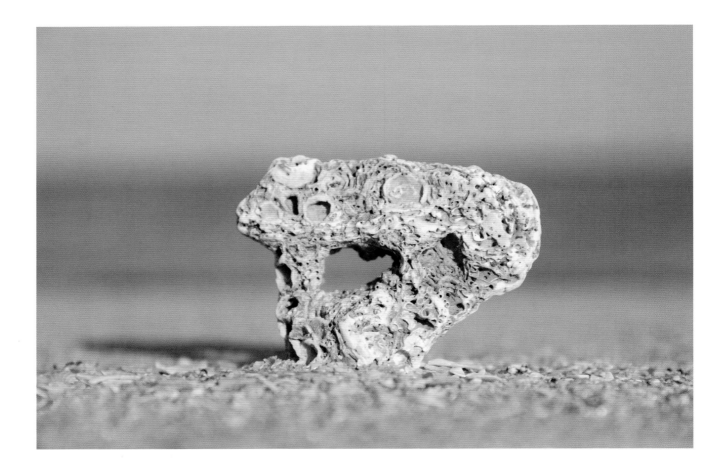

Lighthearted

One of my favorite things about traveling to different beach locations is discovering beach minerals that are different from those at home on Cape Cod. This sand in Florida, with a heavy mix of crushed shells, is beautiful and soft and a perfect setting for this coquina heart.

Heart and Soul

Nauset Beach centers my world, and provides a palette as diverse as any painter's.

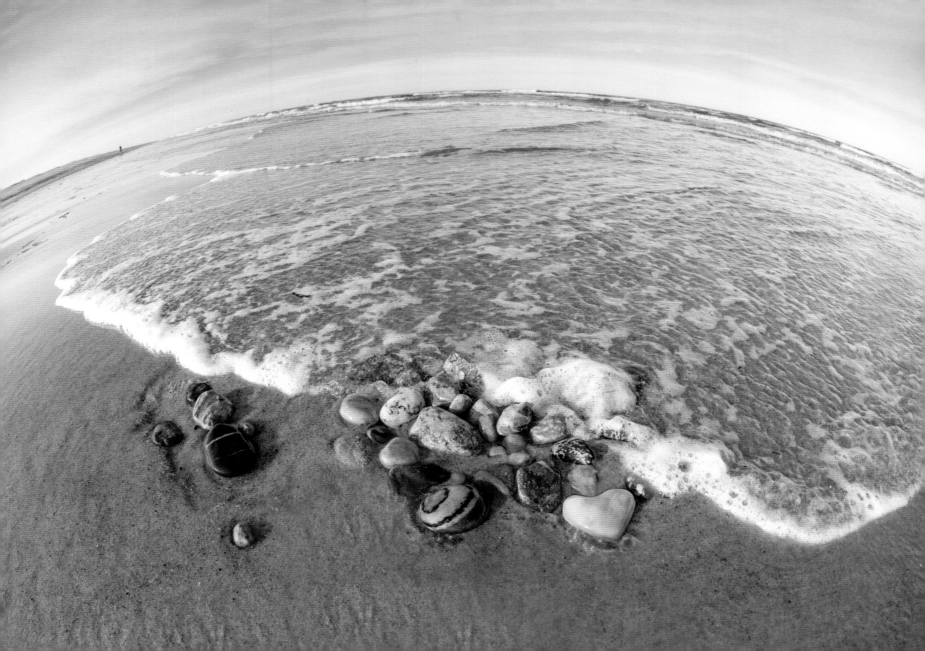

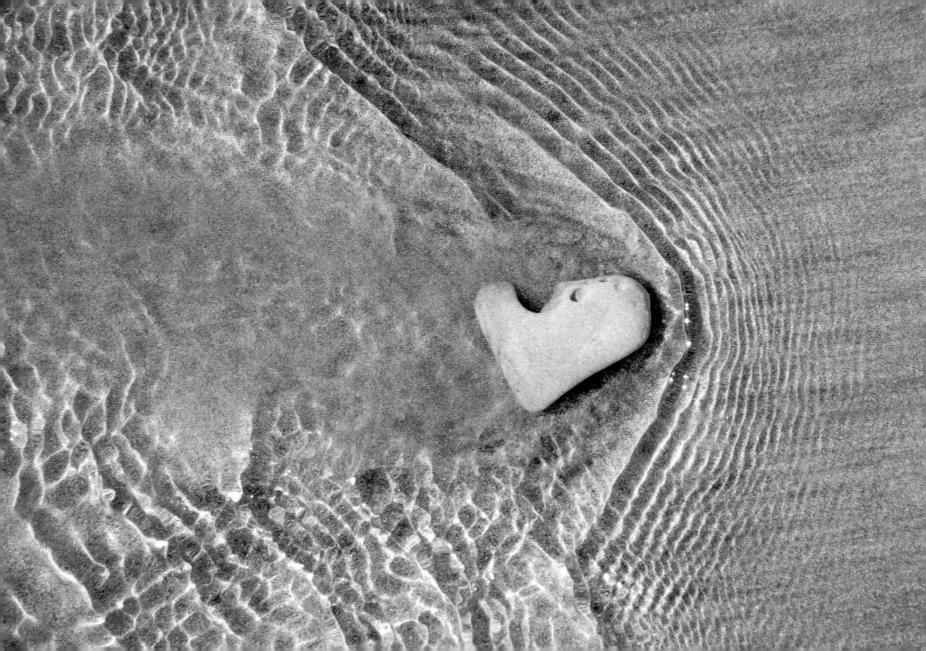

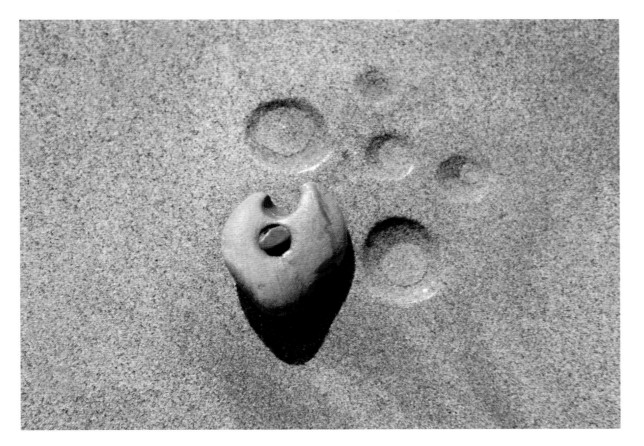

Modern Art

These abstract expressionist–stylized hearts, found and photographed at Playa Guiones, Costa Rica, were shaped by the same forces as the most symmetrical ones, just requiring a bit more imagination, and humor. An akimbo heart is just as precious.

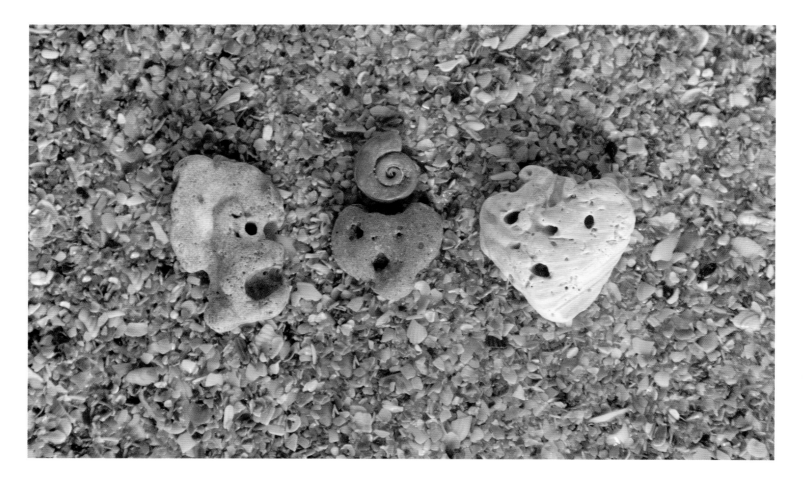

Rock Legends

One of my friends told me when he saw a TV show called *Rock Legends*, he thought of me and wondered what kinds of rocks were being featured. These three are singing, the left a baritone, the middle with the bouffant a soprano, and the wampum on the right with a cowlick is harmonizing. The trio was photographed in Florida.

True Love

This exquisite heart found me in one of my most favorite places, on a day that rocked my soul. It was meant to be, and still serves as an exclamation point in my memory.

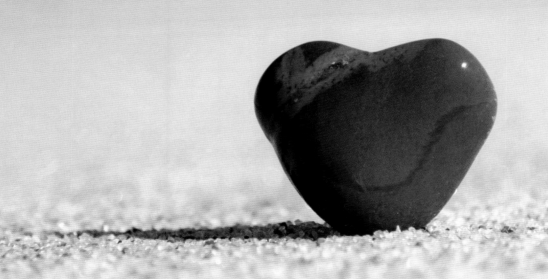

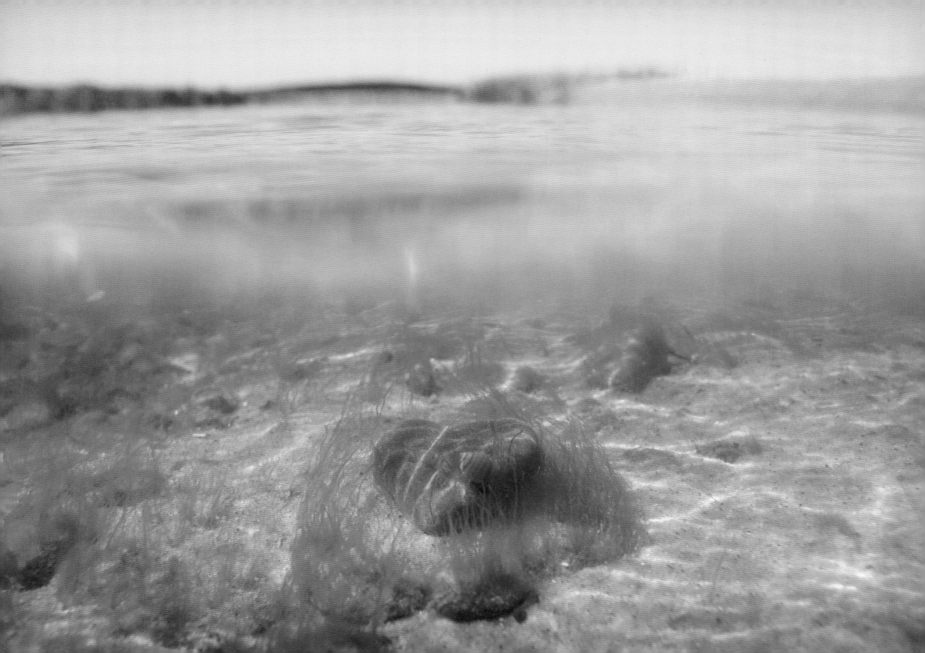

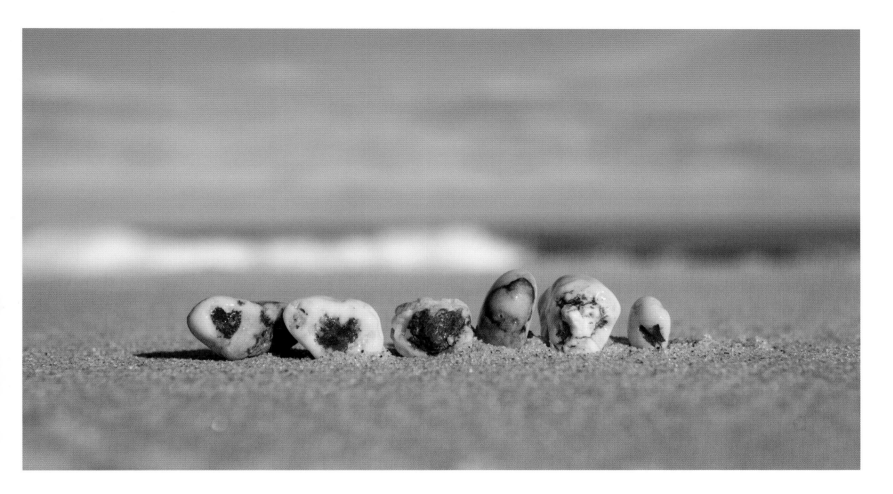

Sunken Treasure

Peeking below the water's surface at Scatteree, Chatham, Massachusetts, reveals an intertidal secret garden.

Family of Six

These sweet black-on-white heart rocks are all from Cape Cod beaches, and bring to mind my brothers and sisters, all six of us with our shared summers on Cape Cod beaches.

Water, Mid-Flight

Photographing moving water is completely unpredictable. The image is usually quite entertaining and editing is always a pleasure. The unanticipated and wonderful movement of the water, frozen in time, can create fortuitous patterns such as the instantaneous and transparent foam heart to the right of the permanent and solid one front and center.

Pot of Gold

The classic reciprocal spectra of the double rainbows prompted a thought. One points directly to this diminutive pot of gold, and although the reverse spectrum diverges as it must, both are wonders, and both equally encourage us forward in their own way.

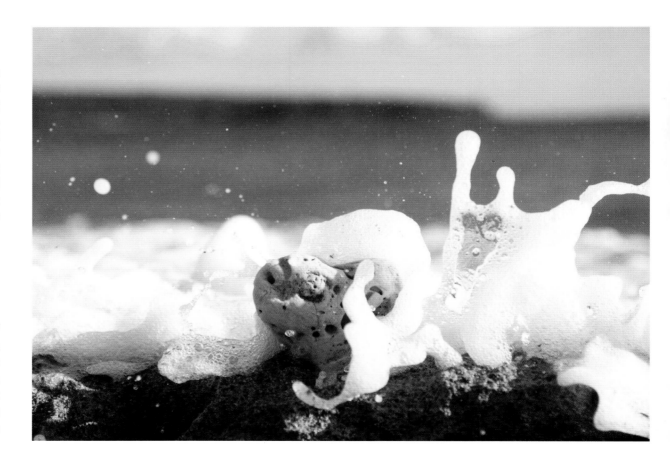

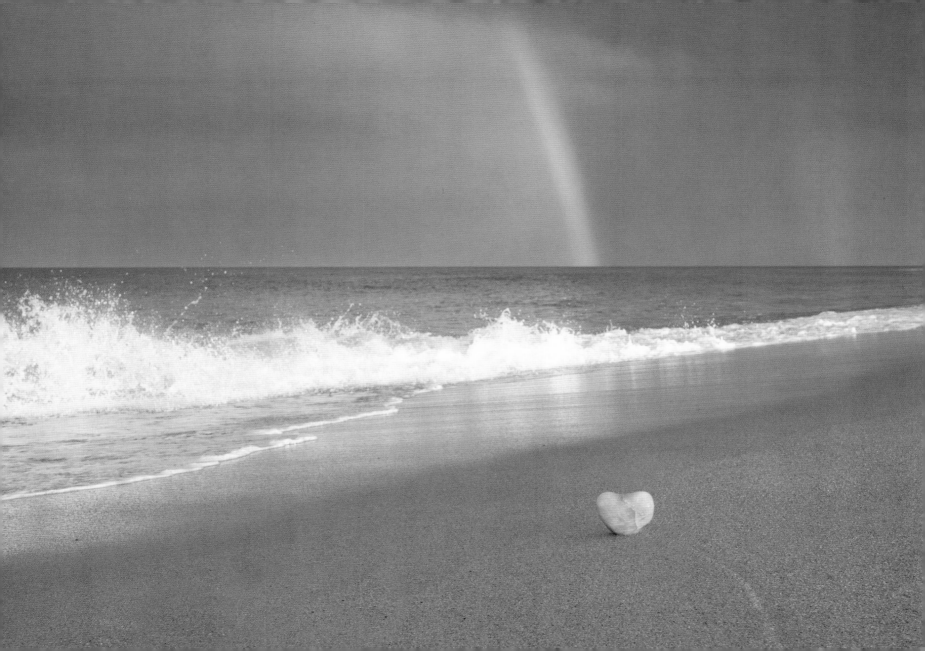

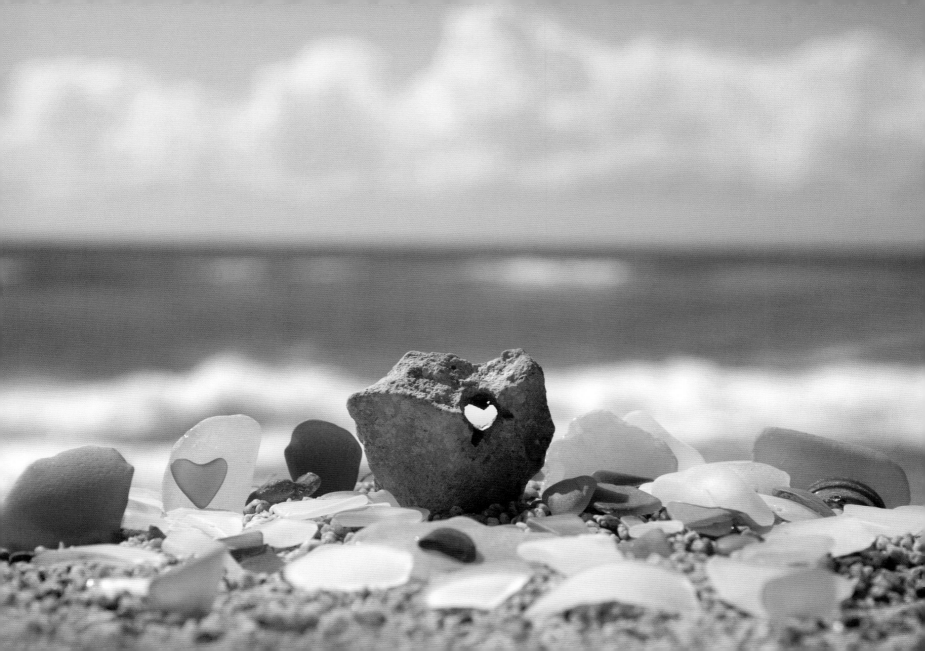

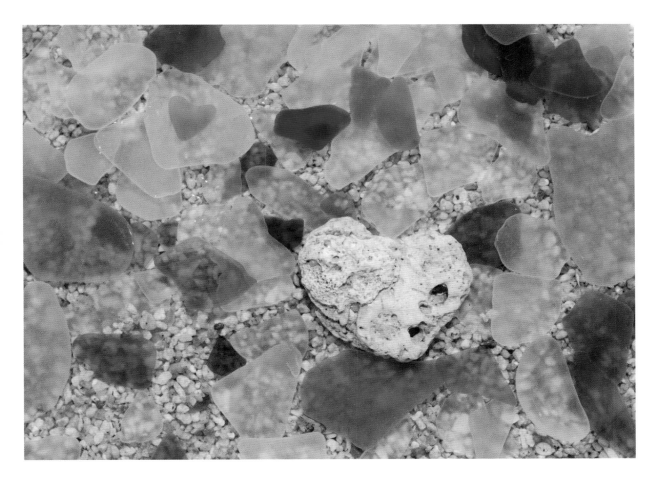

Caribbean Sun

At a stunning Vieques beach, the sun illuminates beach glass and makes this tiny heart window shine, pairing with the delicate green glass heart to the left.

Sandstorm

Beach glass looks beautiful in the water as well as in the sun. I love seeing the shades and colors of the sand underneath the glass and around this heart—sky blue, sea green, and foam clear. Not to mention my favorite green heart.

Valentine's Day

The pebbles seem to gather around the heart, like students listening to a lecture, despite the cold on this February beach.

Holehearted

The many holes shot through this heart make it one of my all-time favorites—damaged but still intact. It found me and I photographed it at Playa Garza, Costa Rica.

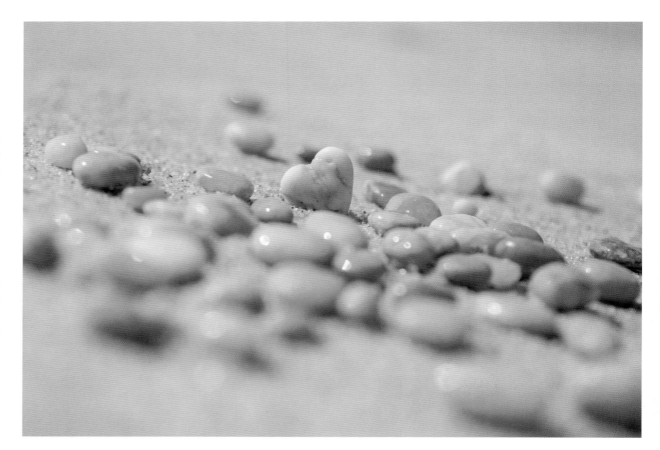

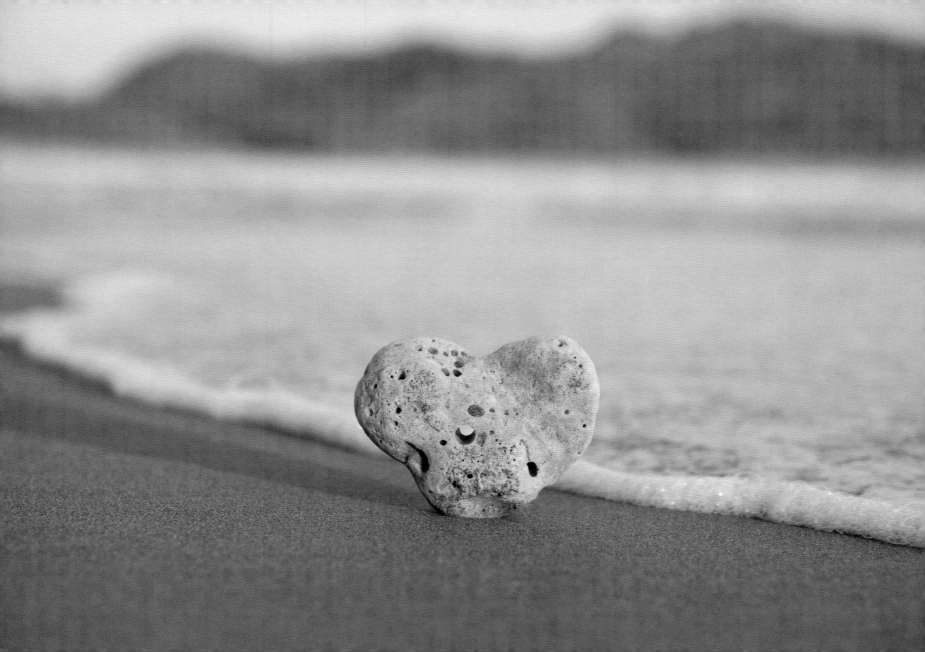

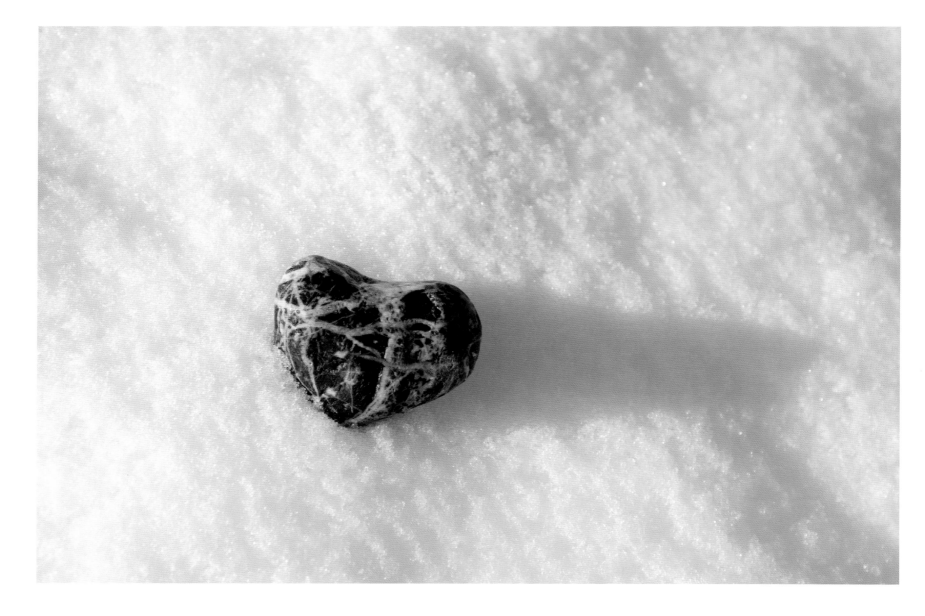

Heartstrings

This heart rock was a gift to me from a dear friend—the strings that appear wrapped around it personify our friendship and bond.

Billowy Bay Beach

Not all days at the beach are sunny and calm. A low gray sky, rain off at sea, and a winter's dusk at Point of Rocks in Brewster, Massachusetts, contrast with the solo heart standing firm in the surf. But there's light in the west, so clear skies ahead.

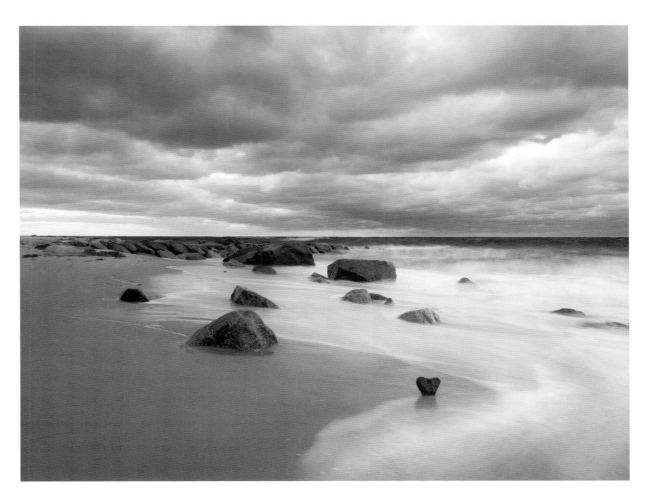

Wind in the Sand

These rippled remnants of a windstorm were captured at the last light of the day after the storm had passed. The sand is very dry and light enough to be wind-blown, while the patterns are akin to the endless motion of the sea that creates the rock hearts that so captivate me.

Missing Lady...
Lost then Found

When you spend abundant time rock-hounding, every once in a while you come across rocks with intriguing faces. This sweet face popped out at me amongst a million other gray stones at my favorite breakwater in Nova Scotia; I darted for my camera, which was only 10 feet away. This is when she went missing—even though I knew exactly where I had seen her, I could not find her again. My sister and I looked for an hour and . . . just when we decided to give up, she found us again.

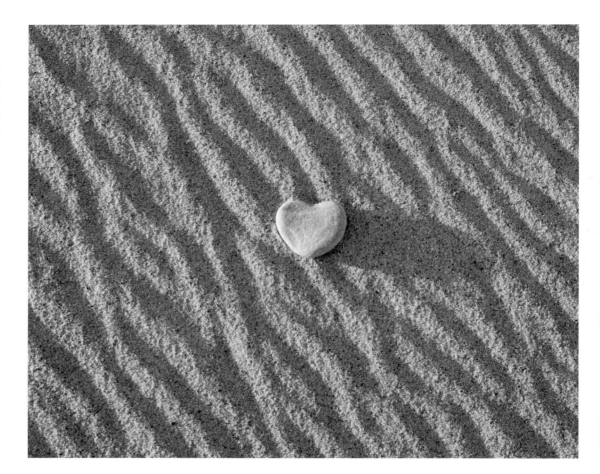

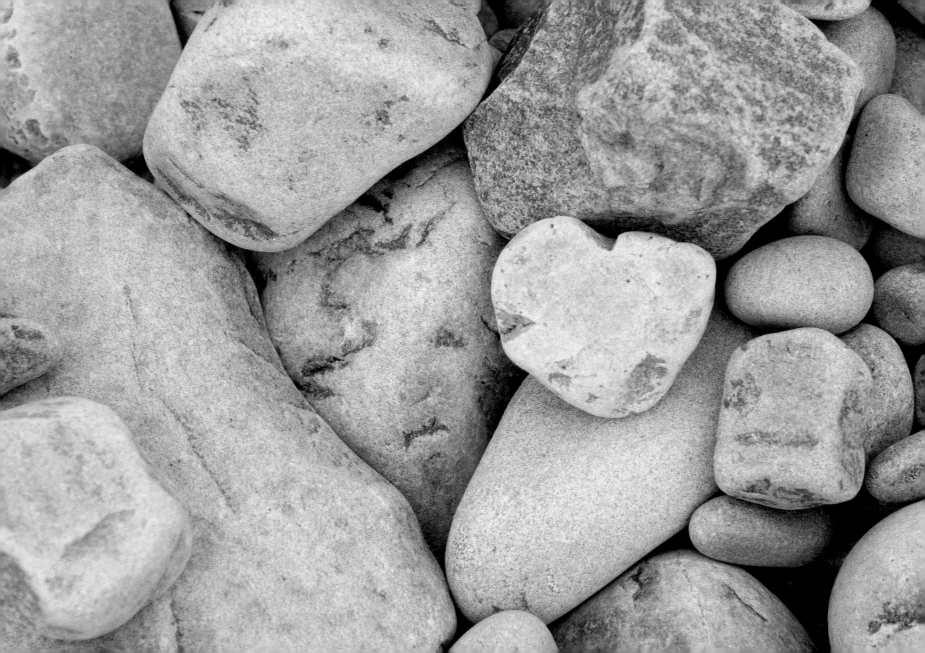

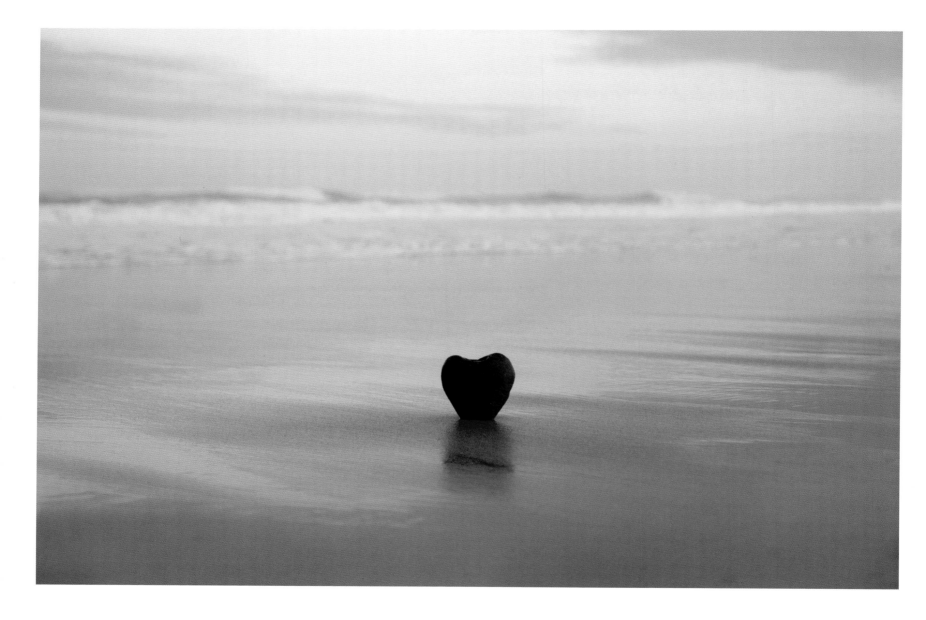

Day's End

A wondrous experience: Staying at the beach until dark, watching the light slowly evaporate, on a tranquil night with the waves breaking far off shore so only the foam reached my feet.

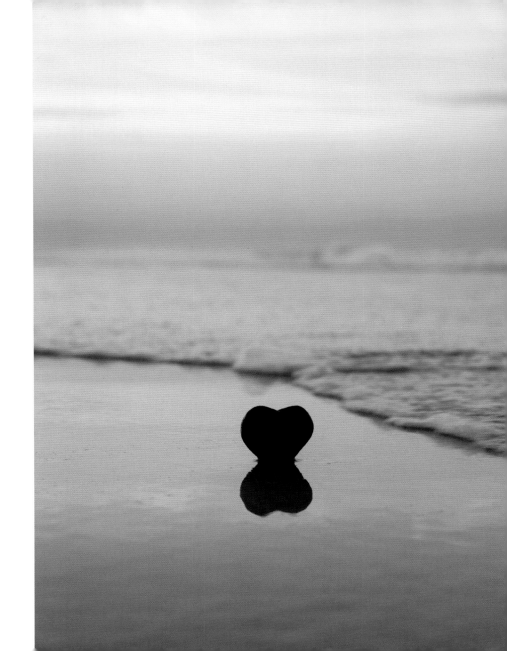

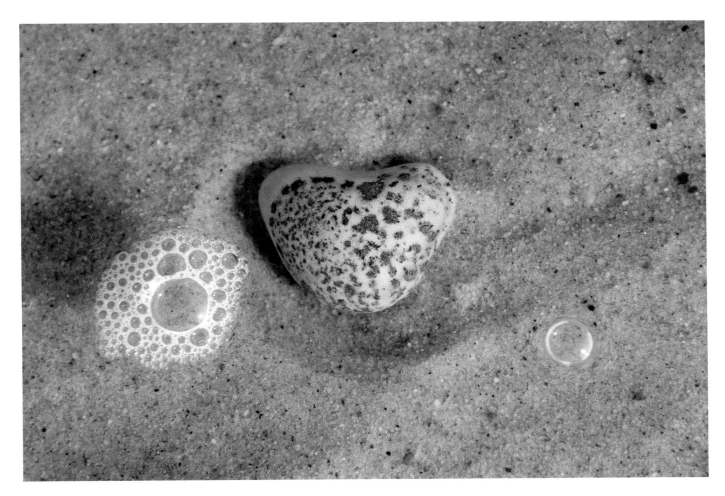

Miniature Heart Balloons

Three of my favorite tiny heart stones, just like an escaped balloon bouquet floating skywards.

Speckled Heart

This rock's heart shape is already exceptional, but then that's augmented by a black speckled heart on the surface, as well as a delicate orange outline of a heart—and all mirrored by a tiny flotilla of sea foam bubbles!

Black Beauty

I decided to photograph this black
heart in the water from above and
below the surface. The first image
is taken from above the water,
exactly as this heart found me on
Nauset Beach. In the second image,
the camera lens is completely
underwater looking up at the surface
to highlight the waterline, surface
bubbles, and the reflection of what
lies below.

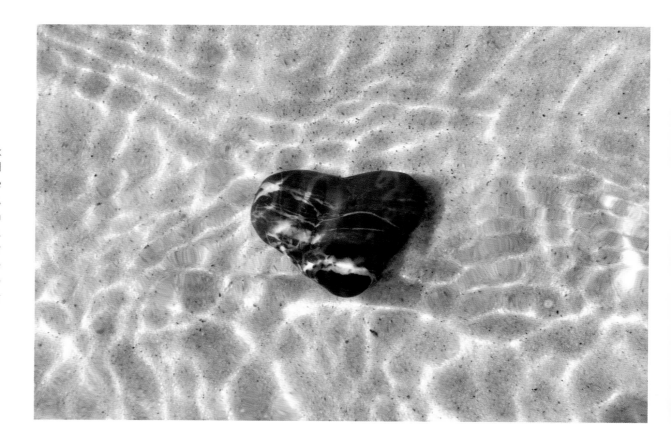

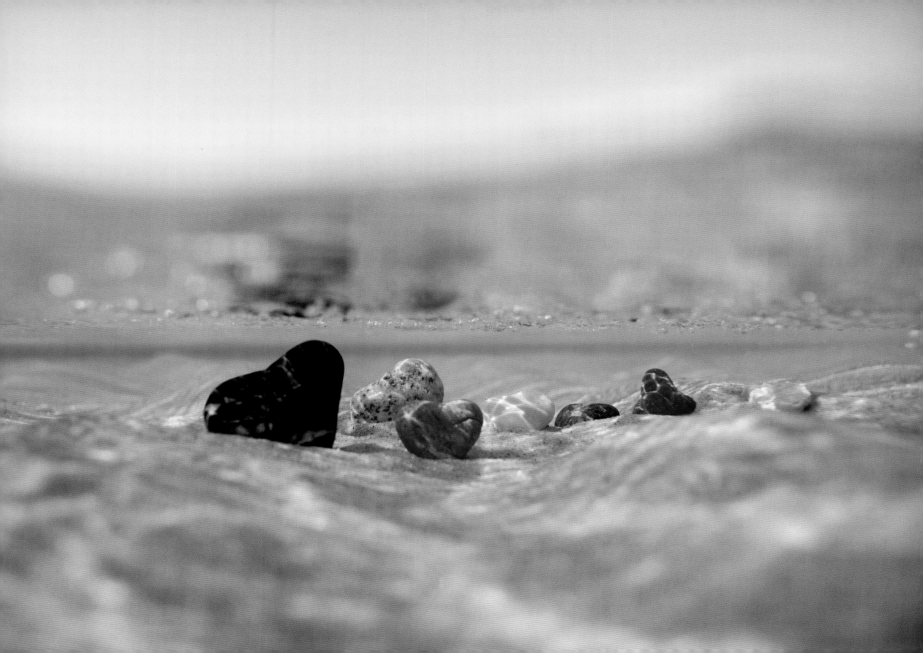

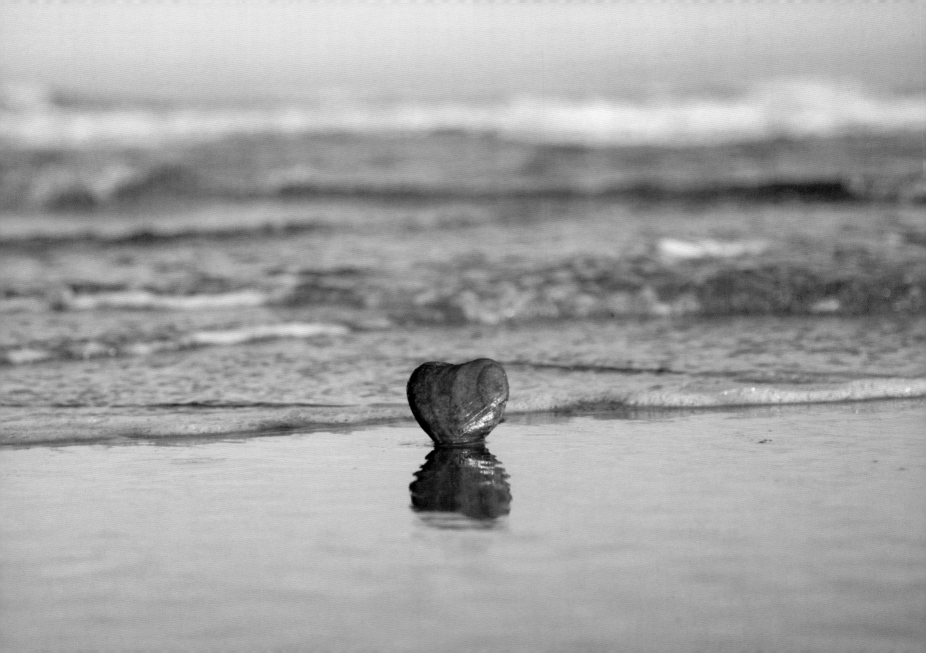

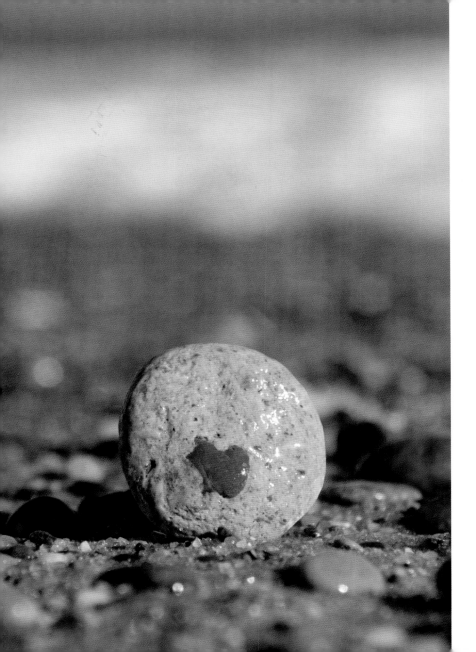

Heart of Gold

When wet and in the sun, this brilliant stone looks like finely polished mahogany. It was a lovely find by a special friend who has a heart of gold.

Rock Candy

The heart on this stone is the same size and color as the fondly-remembered cinnamon-red heart candies of Valentine's Days past.

Heavy Hearted

This heart found me on a large boulder on a lovely late afternoon Nova Scotia hike. The light was serendipitous, since moving the subject was a definite impossibility. Just a little shadow, just a little light, makes all the difference.

Rock Idol

A big heart for a rock idol at home on foggy Louis Head Breakwater, Shelburne, Nova Scotia. We now have a precedent for a bipedal cairn.

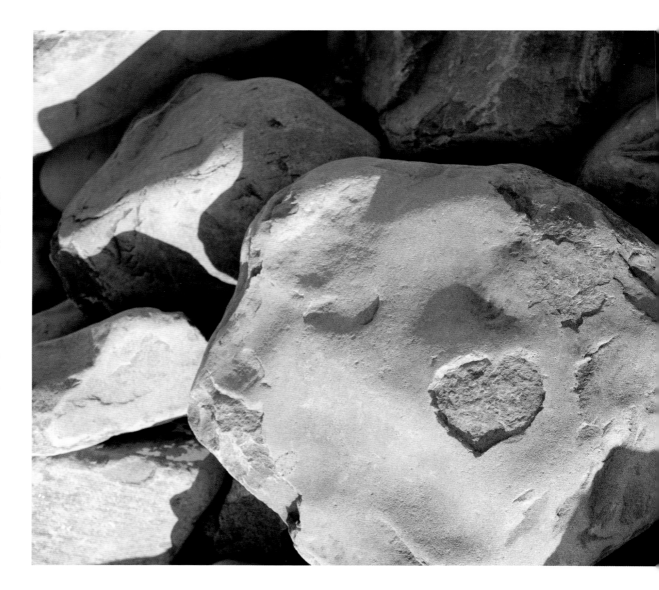

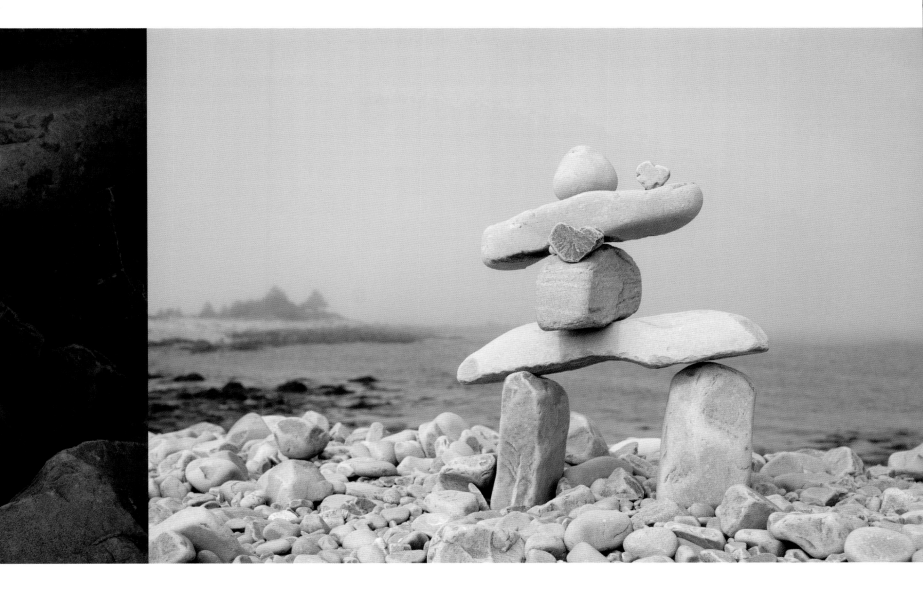

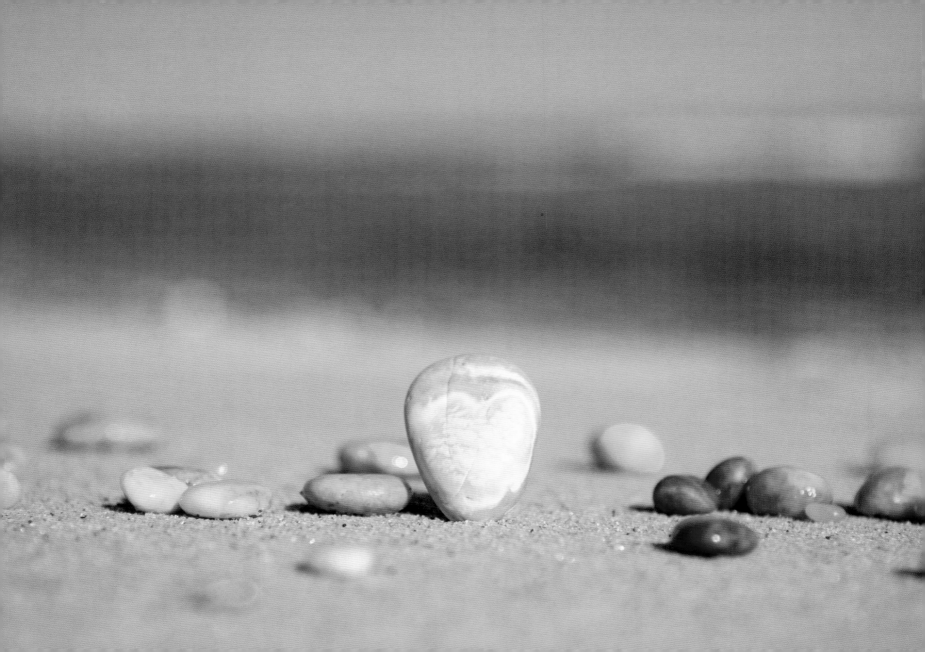

Easter Basket

Jelly bean pebbles surround a soft, white-on-white heart rock. A soft rock is a bit of a contradiction, but the silky matte surface and mottled pattern reminds me of bunny fur, not to mention the green background that reminds me of the cellophane "grass" that still lines many an Easter basket.

Crayon Box

Beautiful beach stones often become more vibrant under water, as light penetrates and reduces the reflected light on the surface, intensifying the color of the stones. When rock-hounding, I will often pick up an interesting dry rock and check to see how it transforms when wet. These are some of my favorite vivid stones from Cape Cod, a cornucopia of color.

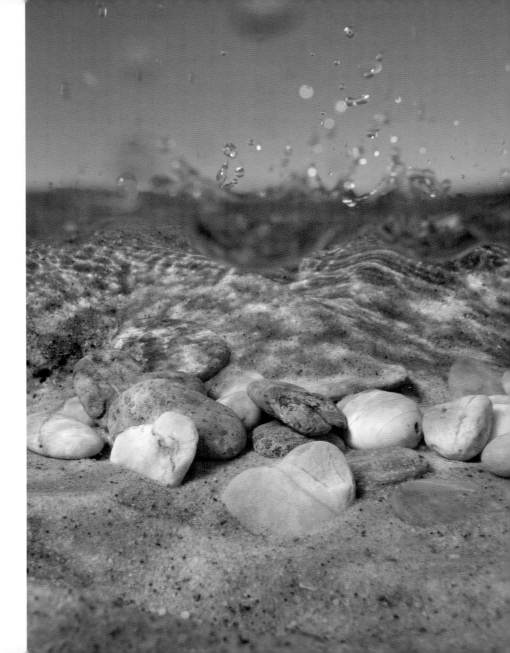

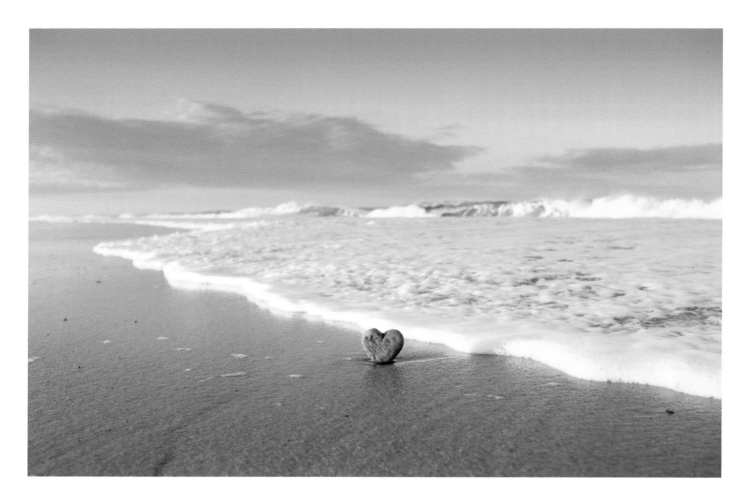

Two-faced Charm

Everyone thinks they have a "best side" for a portrait, but truth be told, any presumed facial asymmetry is dwarfed by the effects of lighting. This lovely heart was photographed on each side in the same location on the same evening, twenty-one minutes apart. Such continuously changing light is just one reason why I love bringing my camera to the beach.

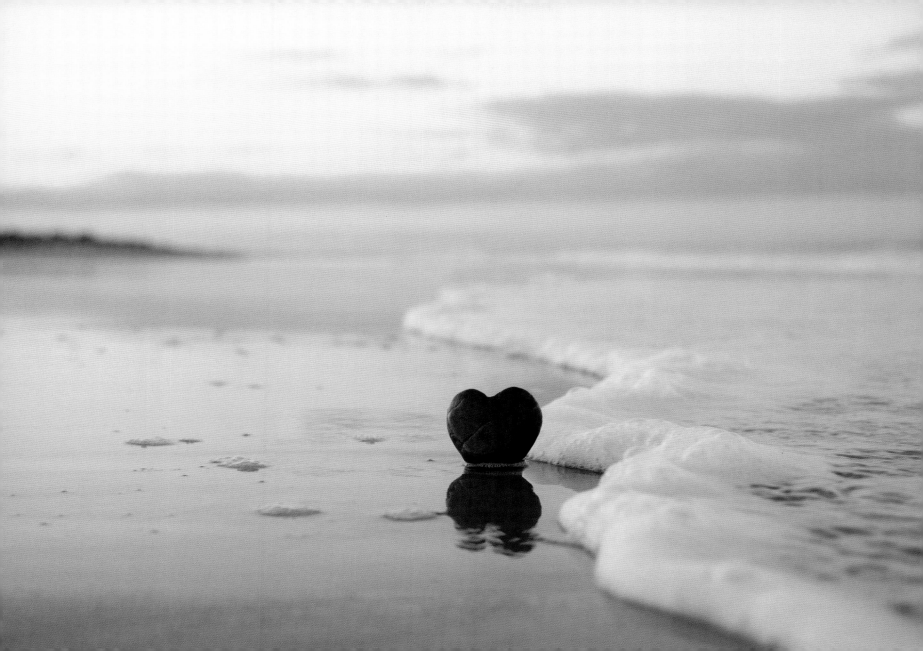

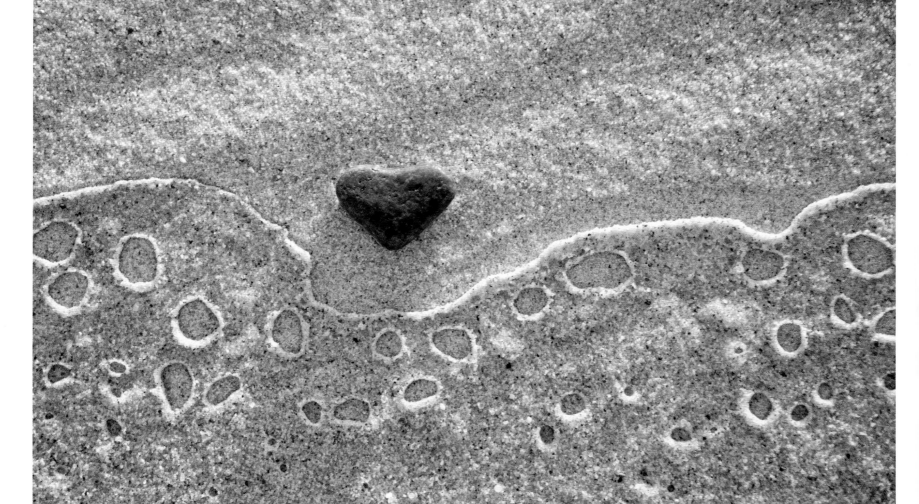

High-Tide Artistry

A wave's foamy ending often leaves delightful patterns in the sand, but it is only the final highest wave at high tide that creates patterns that endure, albeit ephemerally until the next high tide. These tiny sand craters were captured in the day's last sunlight on Nauset Beach.

Autumn Marsh

This Canadian Beauty was photographed in the marsh near the beach where it was discovered. I often drive by this marsh, but it becomes a must-stop when erupting in fall color.

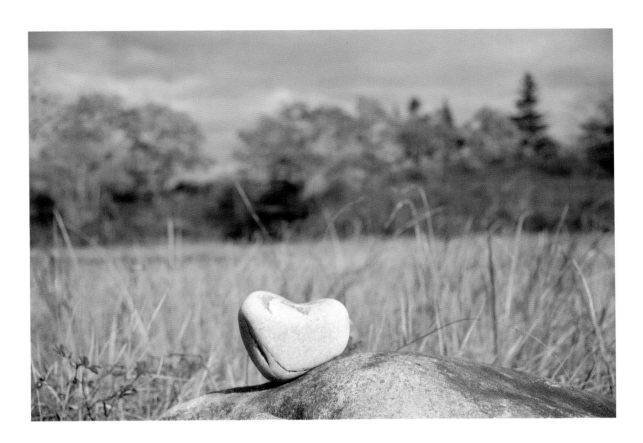

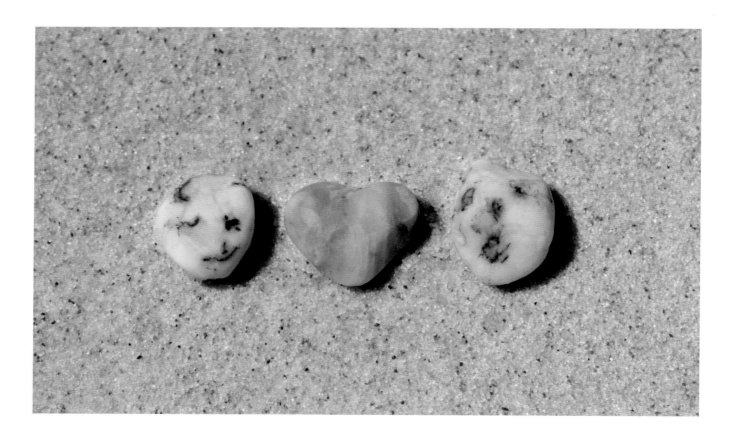

Having a Heart to Heart

Some of the best conversations with friends take place at the beach
Lefty is laughing, while righty is "shocked, shocked, I tell you!"

In a Heartbeat

Capturing the water as it leaps over yet also
embraces this heart at Nauset Beach.

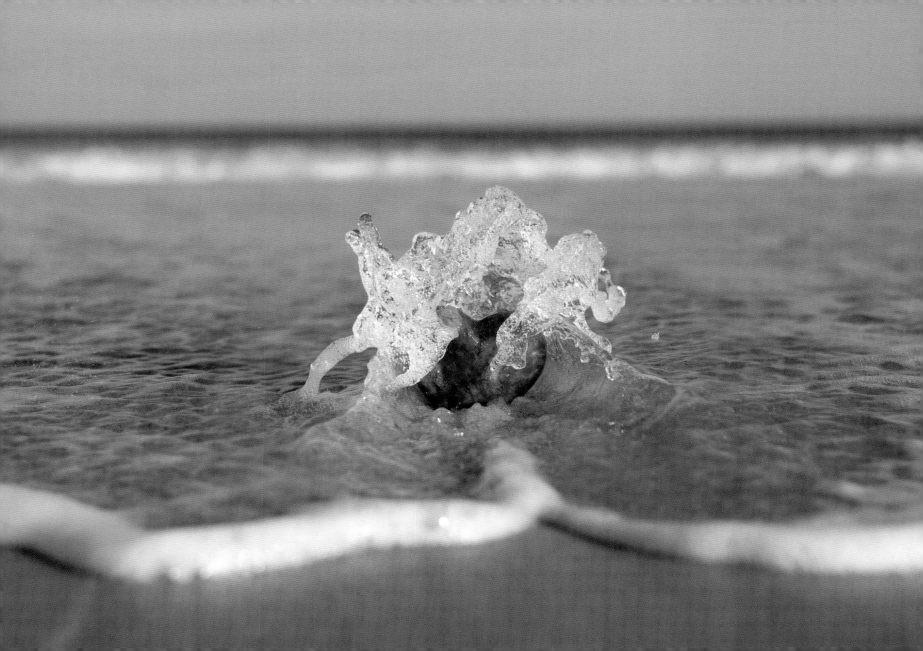

Heart's Desire

A delicate heart floats like a balloon, but has been caught in midair by this stunning rock.

Dancing Heart

This happy heart reminds me of a lively gesture drawing, a spontaneous expressionist sketch with pens simultaneously moving in both hands, capturing the moment and feeling, if not the realism.

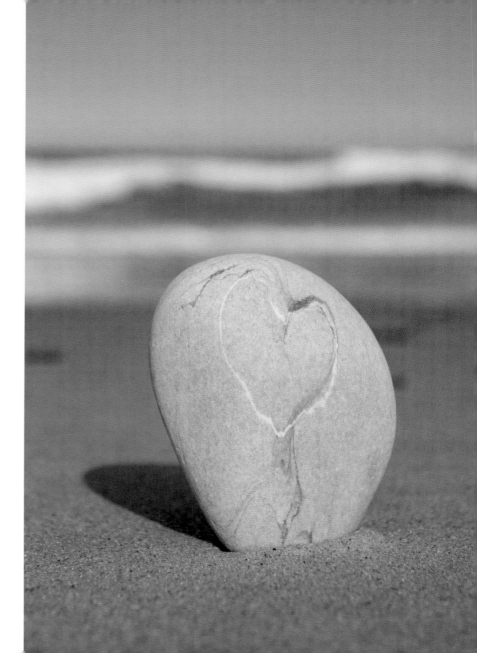

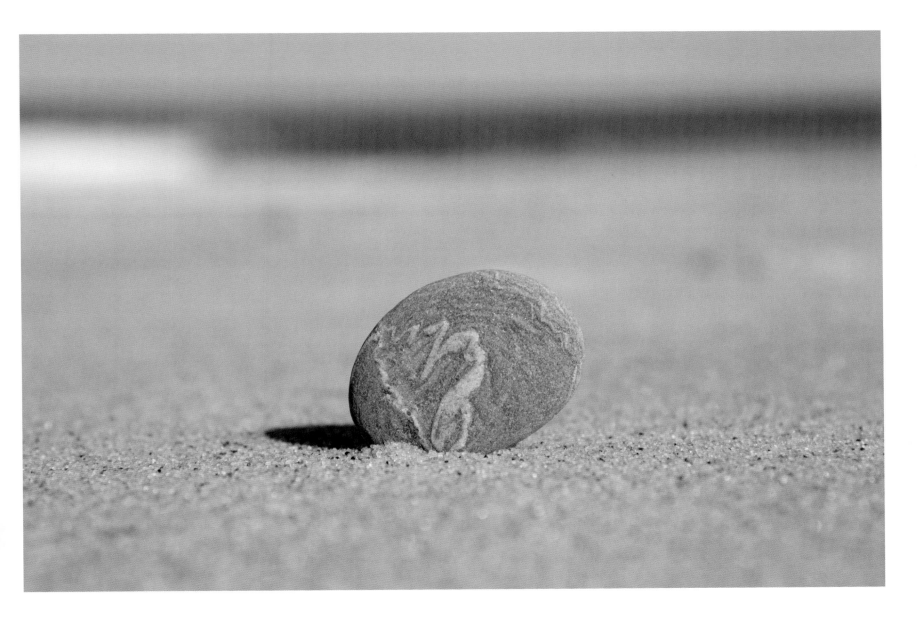

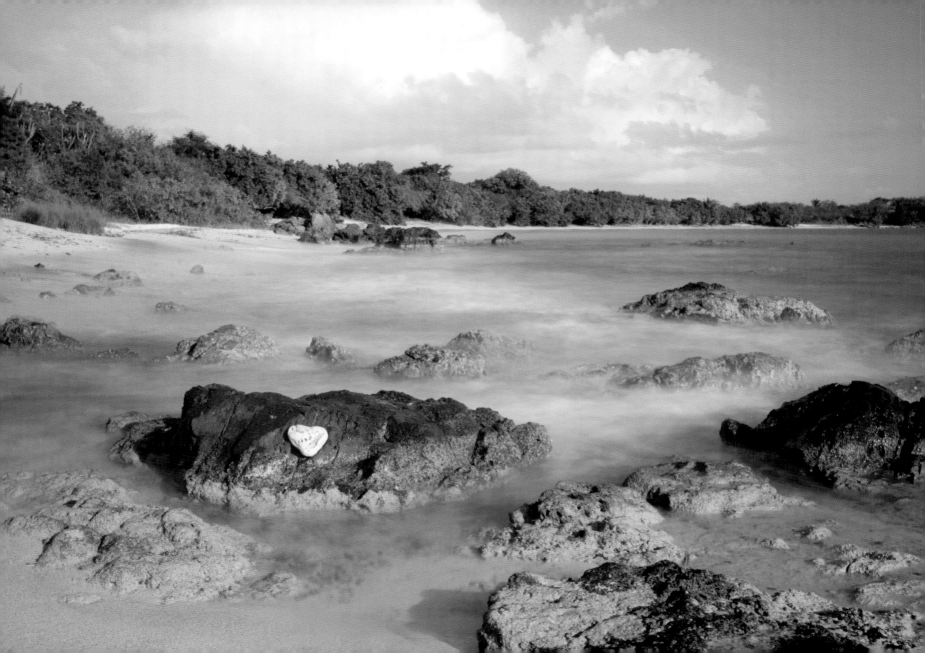

I Spy

Sometimes while photographing a heart in the landscape, I am reminded of the game I used to play with my boys, "I spy with my little eye, something that is _____." Depending on how the player filled in the blank, the opponent would have to guess which "red" or "soft" or "hollow" thing in view the leader was thinking about. It was great for passing time in the car especially on our long drives to Nova Scotia. Sometimes the answer would be painfully obvious, for example, "I spy something that is red" as we approached a stop sign. As my boys got older, they learned to obfuscate and so prolong the game.

I spy something white at a secret beach. Too simple a puzzle for them now, but still capable of prompting fond memories which, after all, is the point.

True Friends

One of the best things about heart rocks is that when you can pick them up, you can give them to friends. Some friends live in your heart forever, and one of them gave this stunning stone to me. A tiny monolith to kindness.

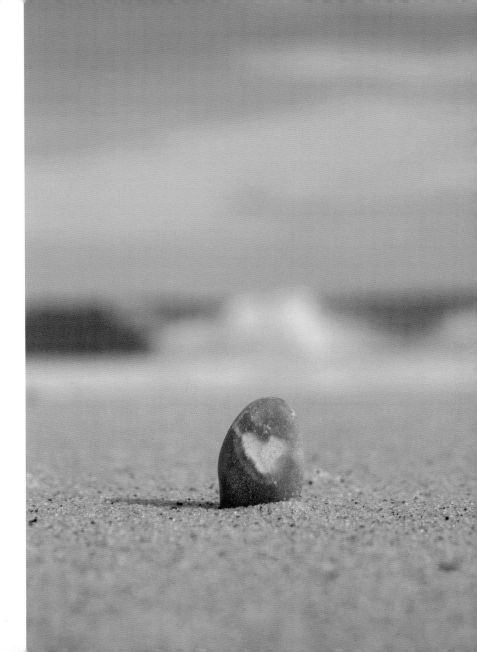

Lucky Me

Some lucky finds amongst
some lucky stripes from a
lucky cove in Nova Scotia.

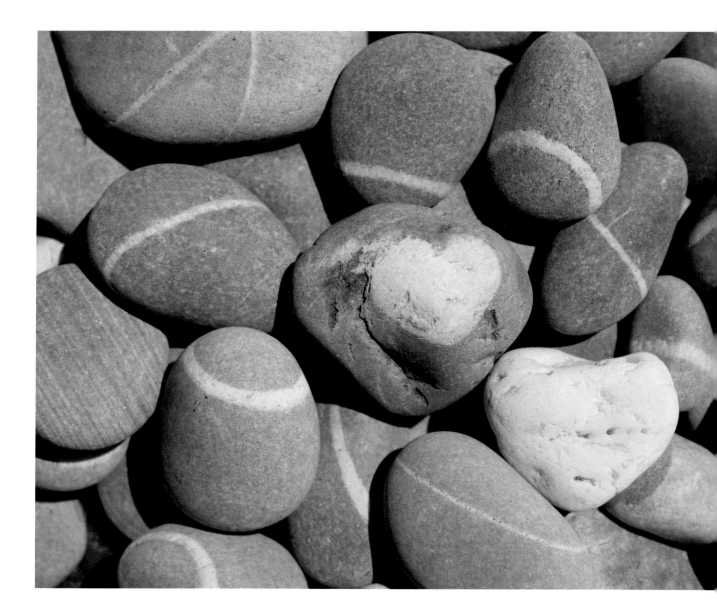

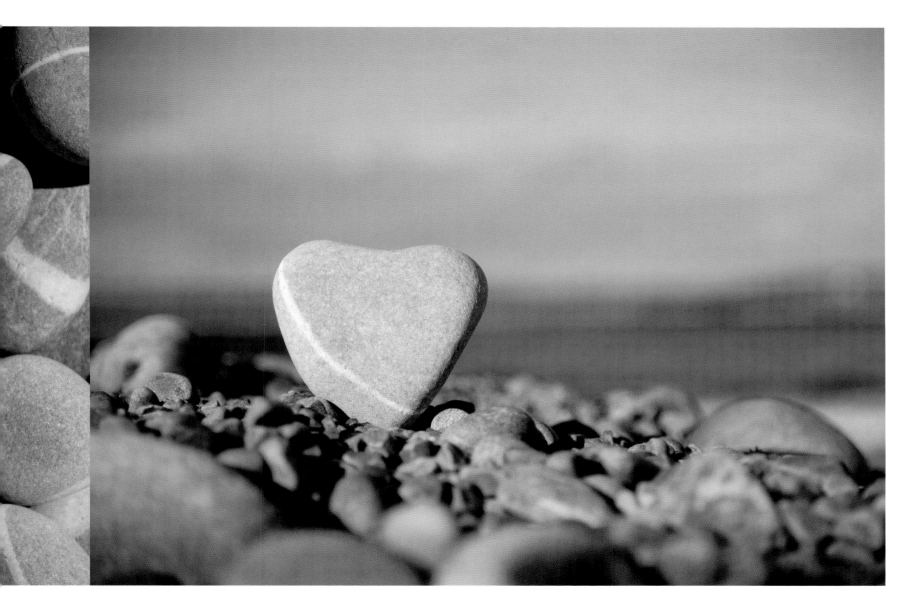

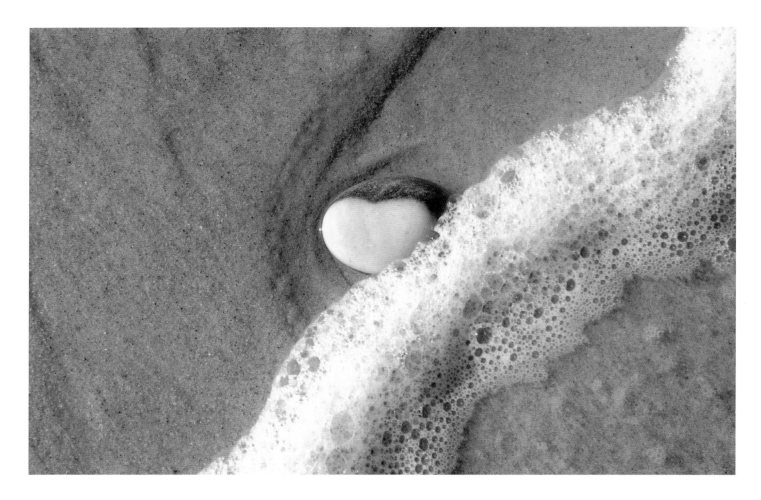

Snowy Owl

This snowy owl has a perfect white heart against a gray background. Although, unlike its namesake, it is hard and heavy, I still imagine it taking flight, leaving sea foam behind.

Stormy Solo Stone

A solitary heart stands fast amidst the expanse of the beach, patiently enduring the end of an autumn storm while sunlight gradually emerges on the horizon. Patience.

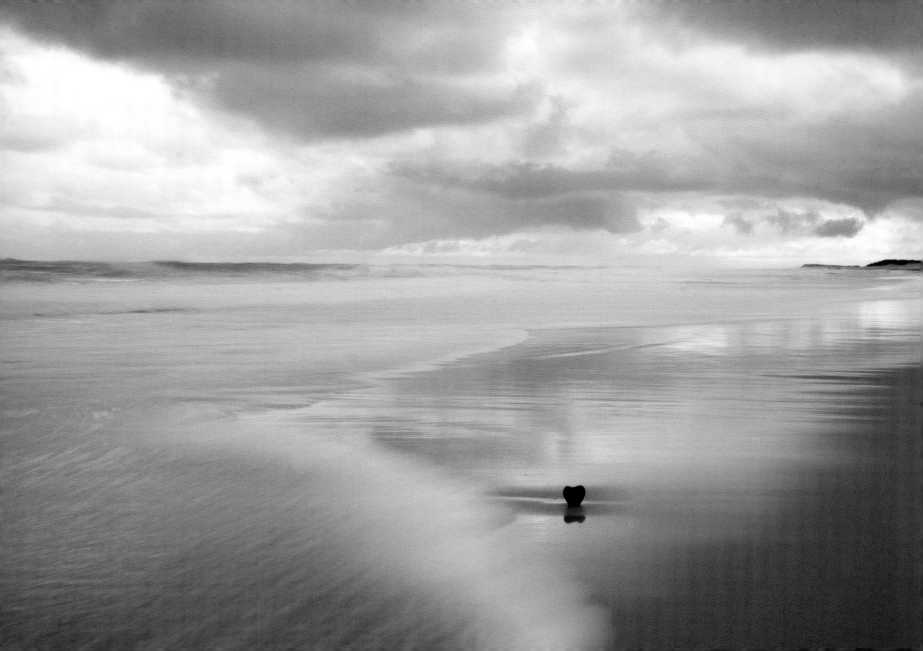

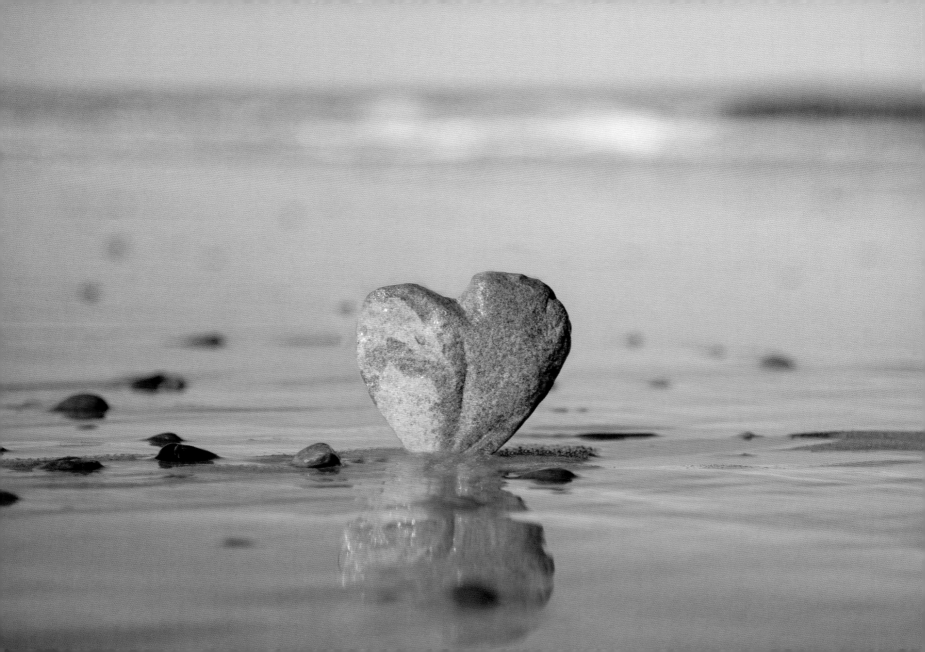

Solid As a Rock

A diminutive monolith, a distant cousin to the megalithic standing stones of Europe. Chiseled and strong, it was photographed as the tide rose on a Cape Cod sand flat.

Light and Shadow

Hearts appear in unexpected places. When heart-shaped space in a stone finds me, I usually hold it up to the light to look through it. However, this one from Georgia showed me that sometimes the shadows are equally illuminating.

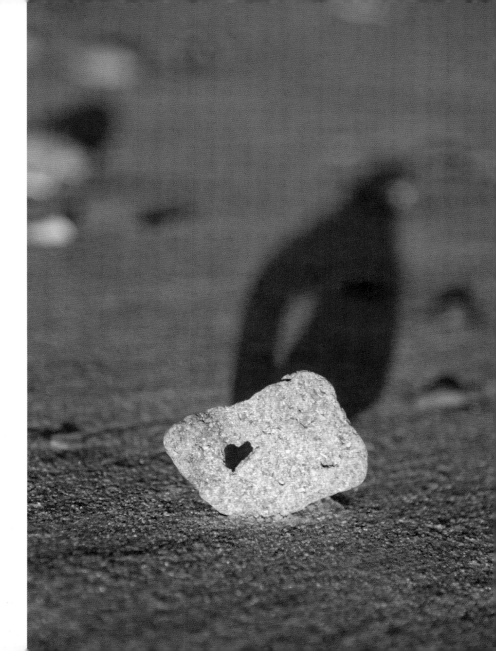

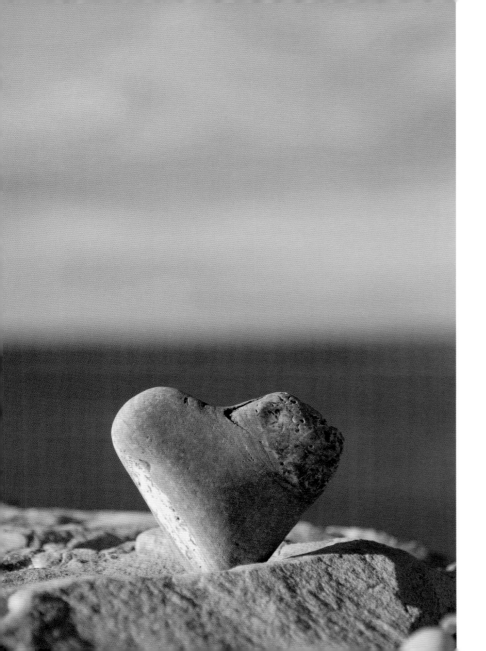

North

Another atrial defect on a Nova Scotian beauty, photographed at the breakwater where it found me. No heart is perfect, but all want to be accepted and appreciated as they are. Every broken heart tells a story. All one has to do to help is listen.

Waves End

It is fun to capture rocks in the water at many different camera angles. The foam around this exceptional rock helps to define its lovely shape while also providing a peek at the kaleidoscopic gravel below.

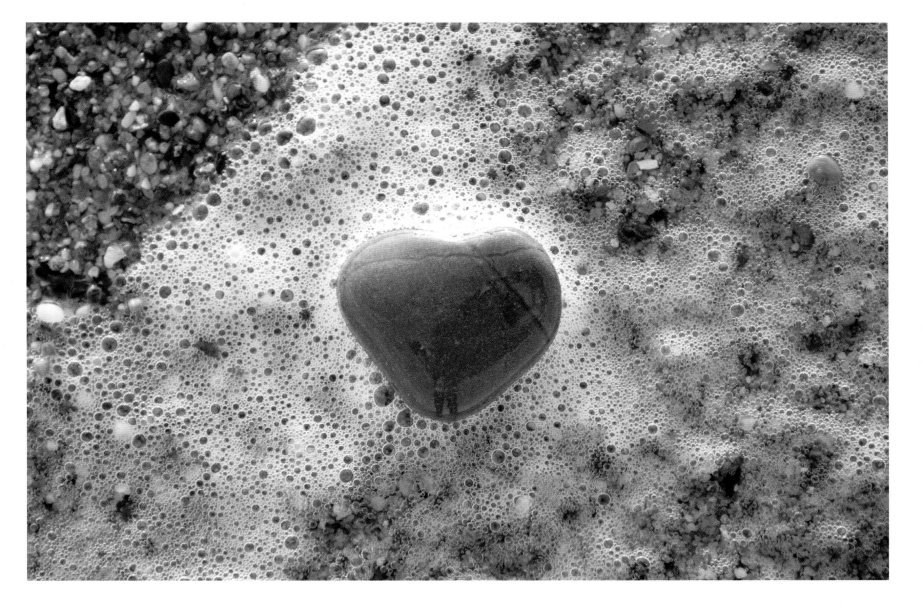

South

The breathtaking and vibrant azures, greens, and whites of the Caribbean Sea complement this gnarly heart and remind me of comparable color schemes at almost all beaches in the right light.

Doodling

It may have been lost, but a wandering beach critter thoughtfully left a heart in the sand to accompany this sweet heart stone.

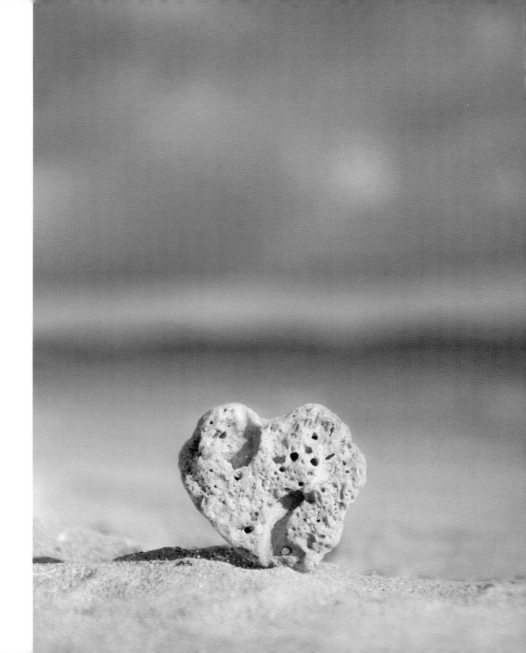

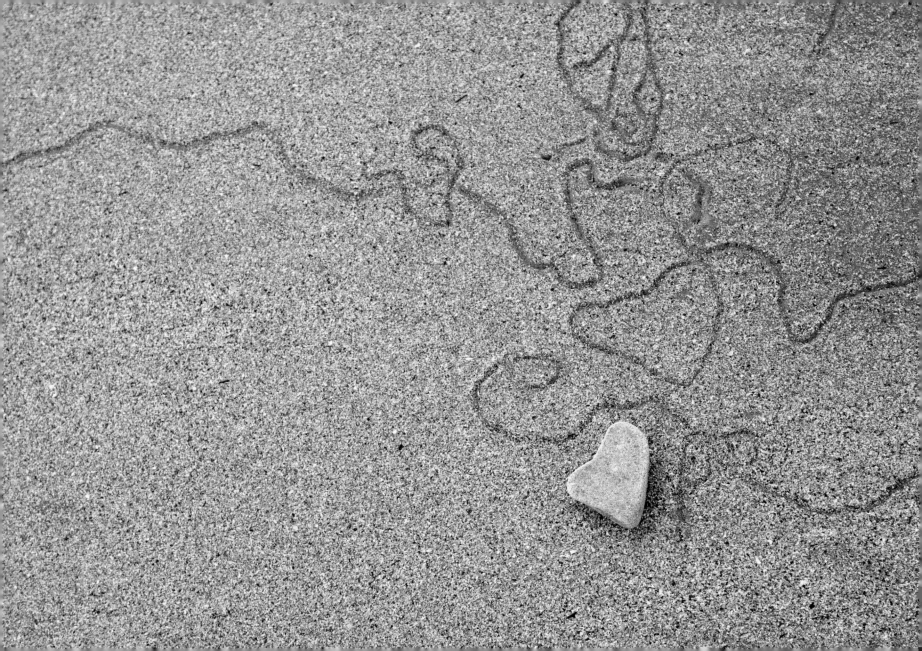

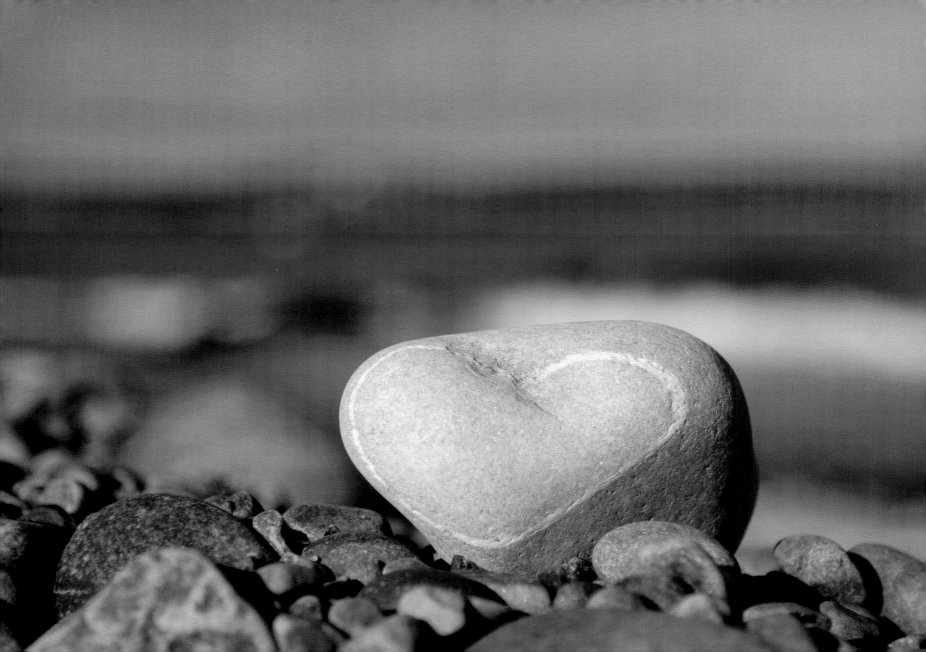

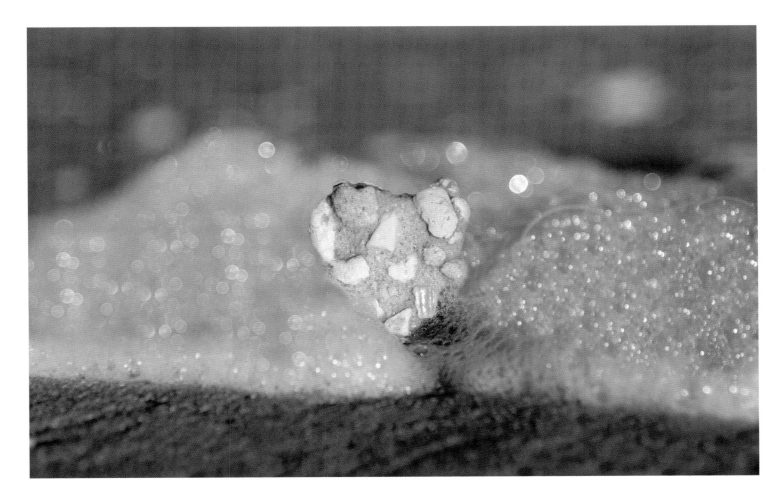

Chalk Line

A simple white line defines a heart, feeling the love and not easily erased.

Southern Heart

This amazing Florida sandstone accretion, with other stones and shells attached, hosts three tiny hearts. Like us all, we find and sometimes cherish forever the hearts of friends throughout our lives. It's nice to keep them close, as this rock knows.

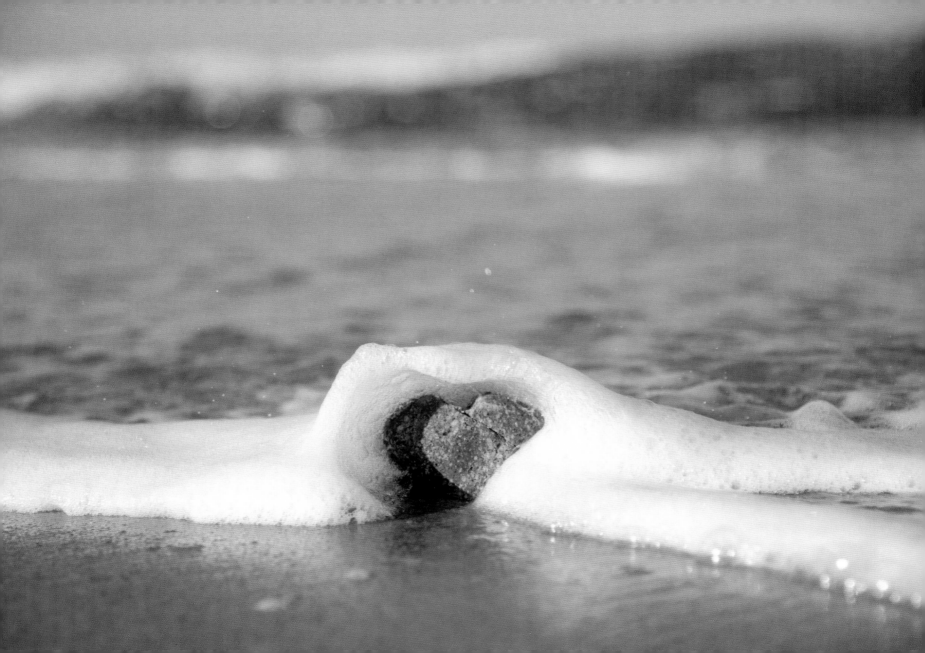

Heartbroken

A dear friend gave me this rock from Chatham, Massachusetts, on a day when my heart had been broken. She reassured me that, even though it had a crack, it was still a perfect heart, reflecting our friendship, always supportive with a ready hug.

Beachfront Beauty Queen

This bathing beauty won my heart at Sun Bay, Vieques. Somebody, I imagine a couple of playing kids, has a sense of humor I can appreciate!

Hollow Heart

This shell and heart are meant to be together. Sometimes broken shells are imperfectly perfect, bringing us sweet little hearts, as though the stone would exactly fill the shell's void.

Fish Love

When I spotted this fish-head stone with an eye and mouth, I couldn't stop myself from fleshing it out with some heart stones. No small bones to contend with, but still not great eating.

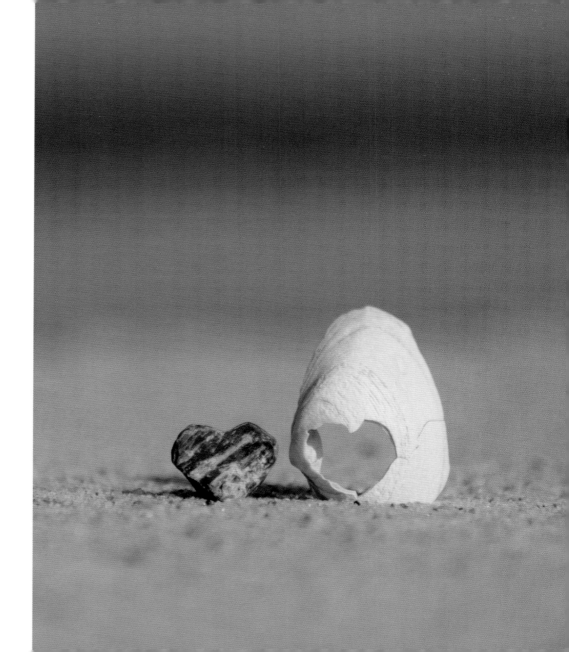

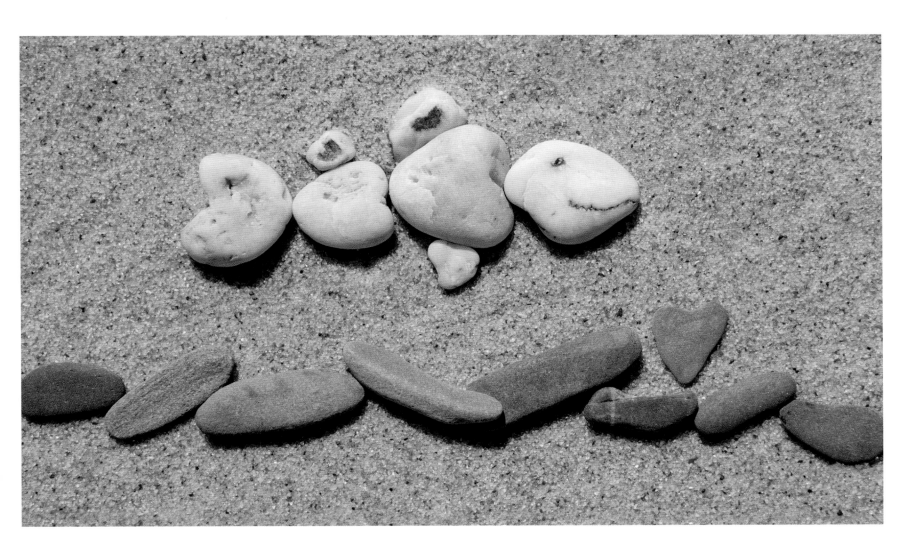

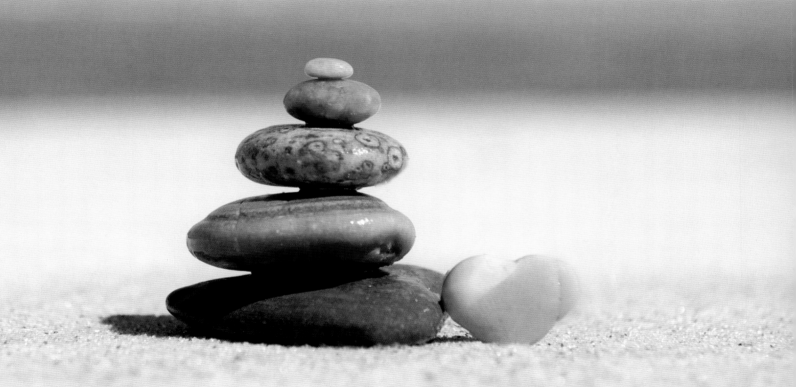

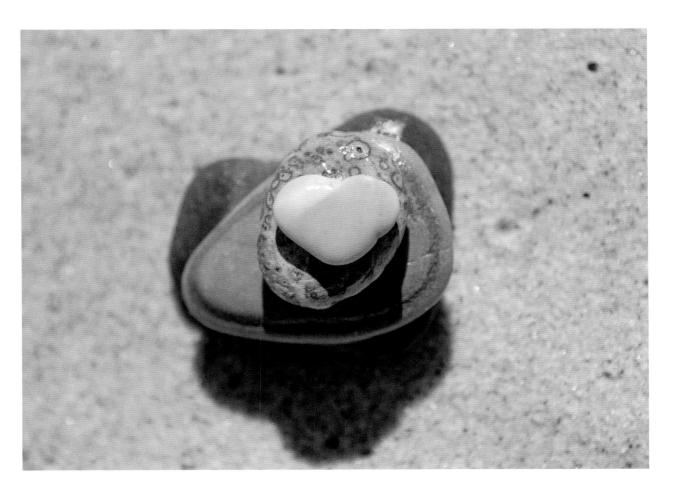

Butter Yellow

At some beaches, the stones come in a myriad of colors, shapes, and patterns. Making arrangements of these stones brings me lighthearted pleasure, and I hope to you, too.

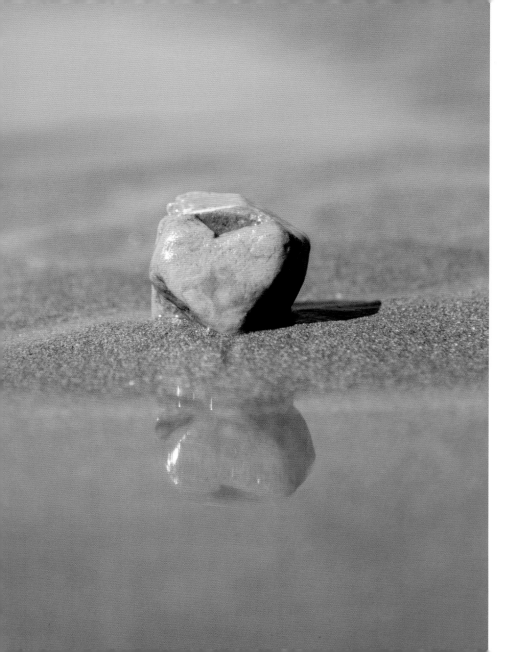

Carved in Stone

This Costa Rican beauty appears to have been painstakingly carved on the surface of this stone—a lovely find at Playa Garza.

Partners

These two best buddies found me at Nauset Beach at the same time and within a few feet, a quartz couple forever.

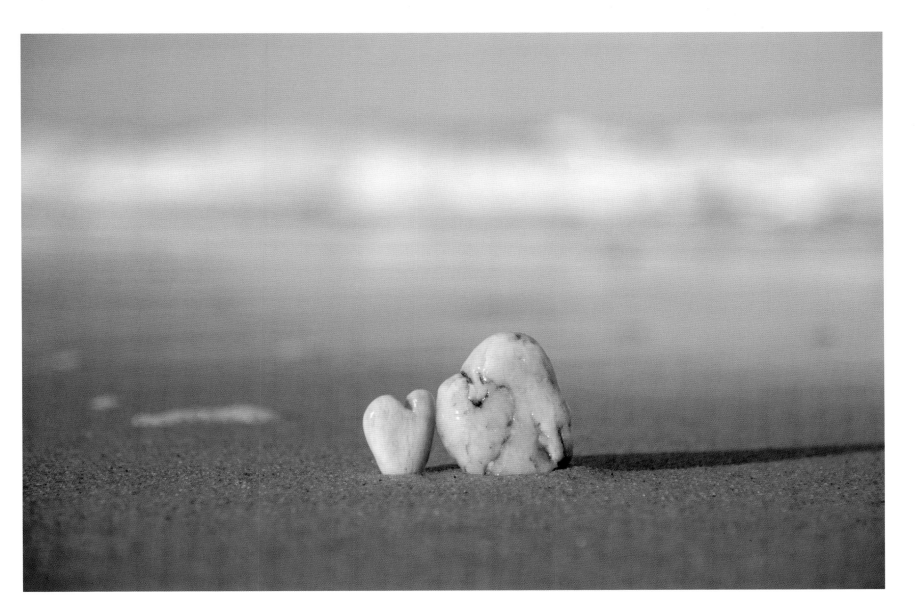

Soulmates

Though found over a thousand miles apart, these two rocks were destined to meet. The larger one found me exactly as it was photographed, on coarse dark sand in Nova Scotia. Its reciprocal counterpart traveled from Florida via a friend who gave it to me years ago, and I've always kept it close as a reminder of how delightful generosity can be.

Fire and Ice

Have you ever seen a golden sunset light up snow? Difficult to see looking down, you must get your head on the ground and look at the final light of the day as it skims across the snow . . . beautiful, like frozen wave seafoam.

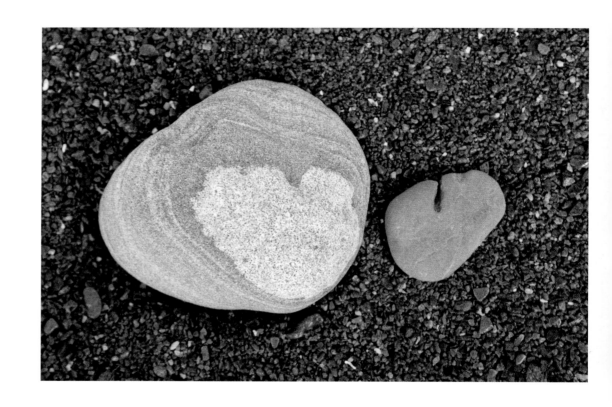

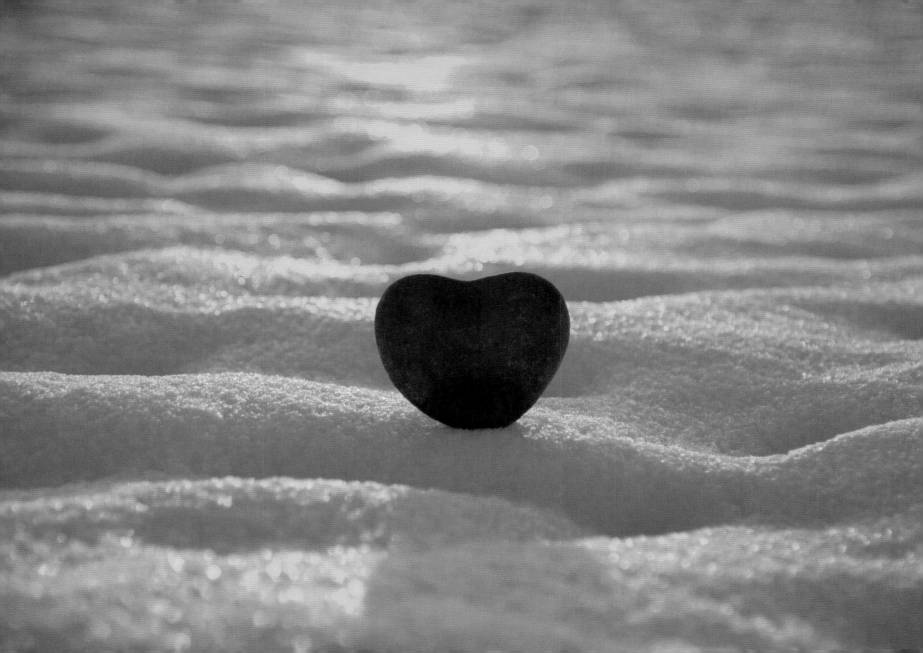

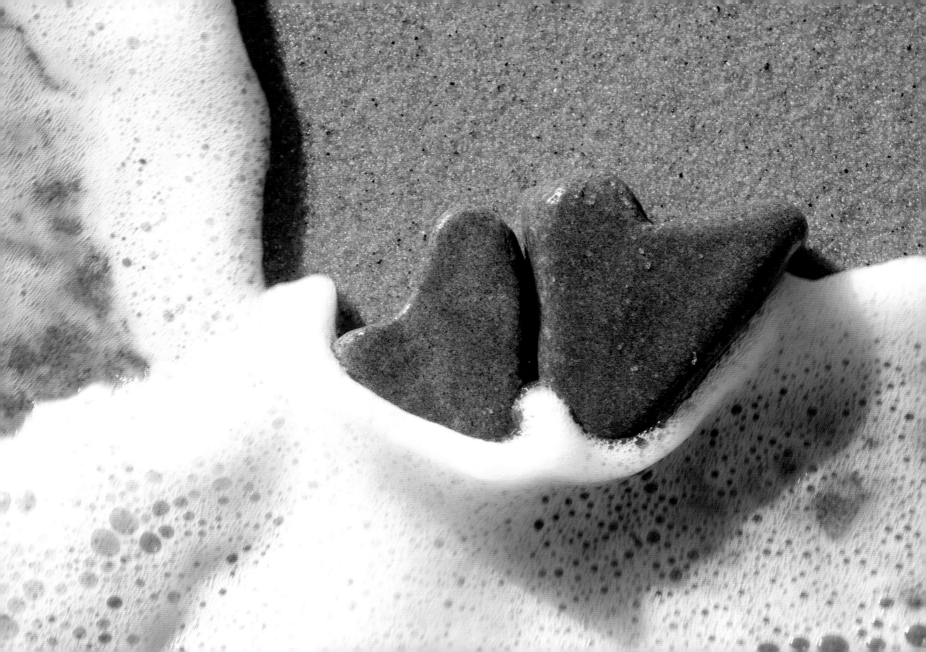

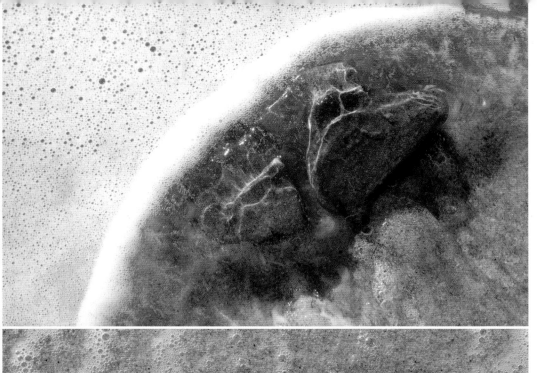

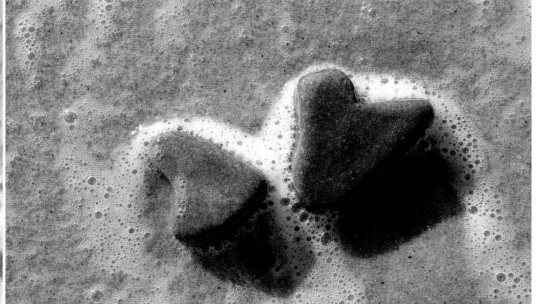

Another Couple I Know

Fitting perfectly, these two rocks were made for each other, and obviously still like to swim together.

High-Collared Hearts

A cozy Elizabethan foam collar momentarily protects these hearts from the incoming tide. But soon, like fashion, everything will change.

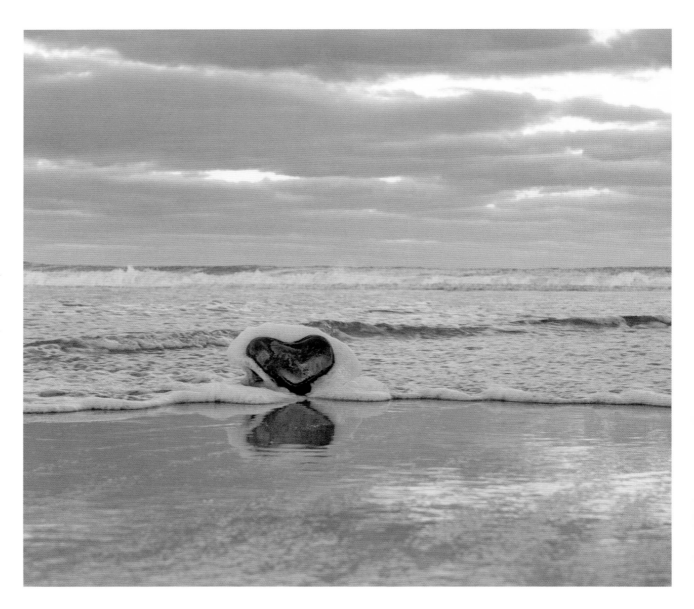

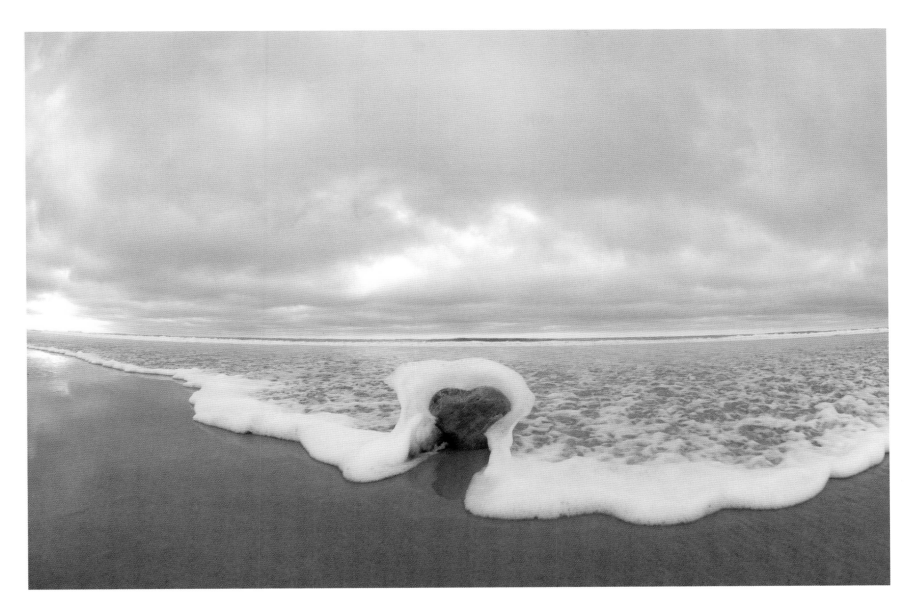

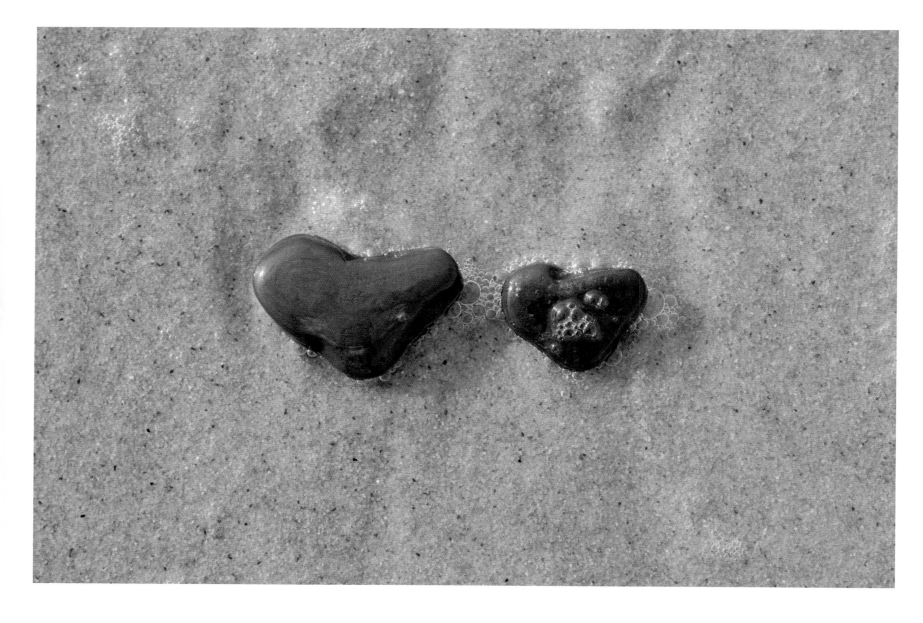

Mother's Day

Shared rock-hounding readily cements a friendship. While looking for hearts on Nauset Beach with a dear friend, he came up with a very dark, oddly shaped heart. The instant that I saw it, I told him I had a very similar rock at home, found in EXACTLY the same place a few months earlier. The day my friend found this "baby" rock was Mother's Day, and I still think of these two as a family.

Thanksgiving

Taken on a stormy Thanksgiving morning, the image feels cold. Actually it was a warm and beautiful day with constantly changing light, a major reason why I love the beach so much—always another surprise just around the corner.

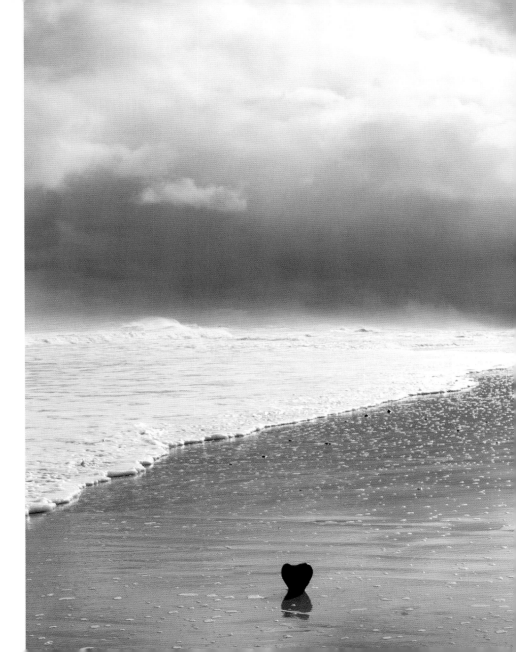

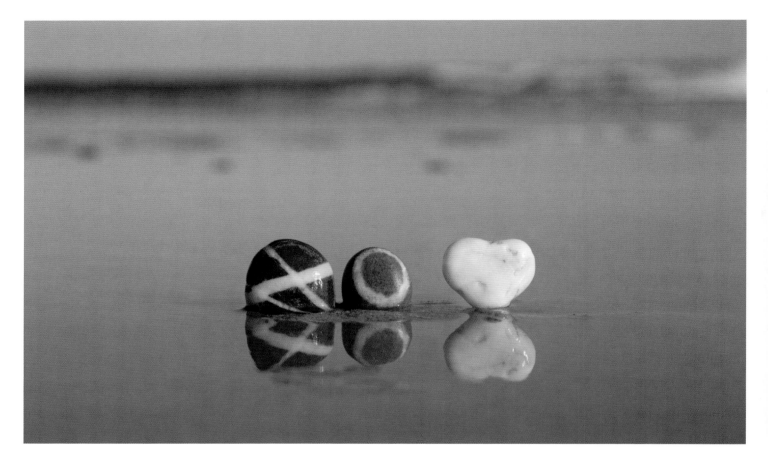

A Kiss and A Hug

We all love Xs and Os . . . especially at the beach.

Catch a Wave

When crouched down, ear in the sand, awaiting a wave, I am trying to capture so many things at once—the bright green color of the wave as it curls against the dark blue of the ocean and sky, the white crest, the airy foam. Sometimes it takes many attempts and much patience. When photographing waves, I am often struck by the disparity of the strength and weight of the crashing wave and the airy weightlessness of the foam at its journey's end.

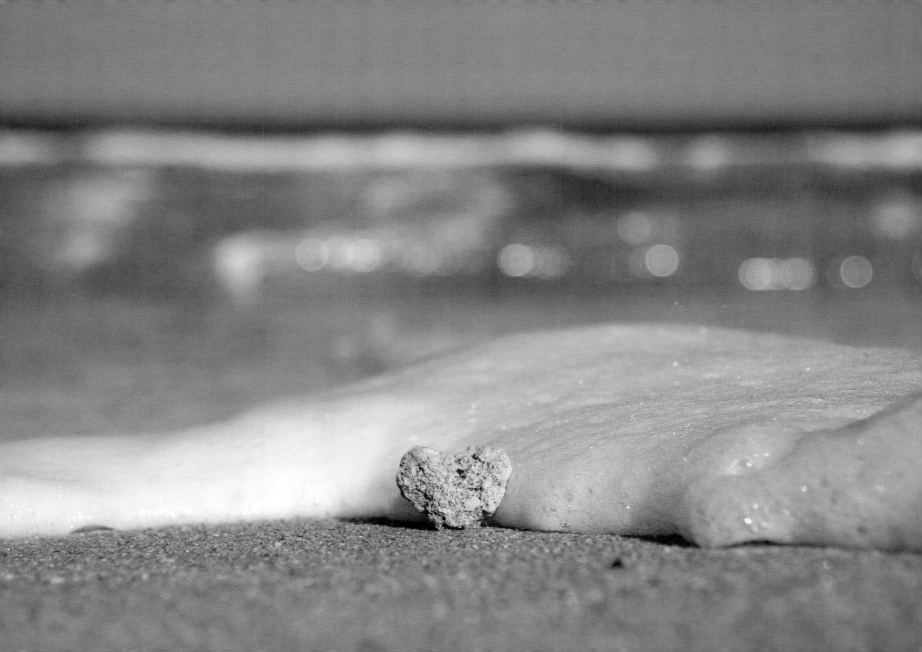

Heart in the Hand

A spectacular heart held by my son James,
who has an extraordinarily kind heart
and an ever-open hand.

Crashing Heart

Sometimes the incoming waves look like
giant hearts hugging the beach.

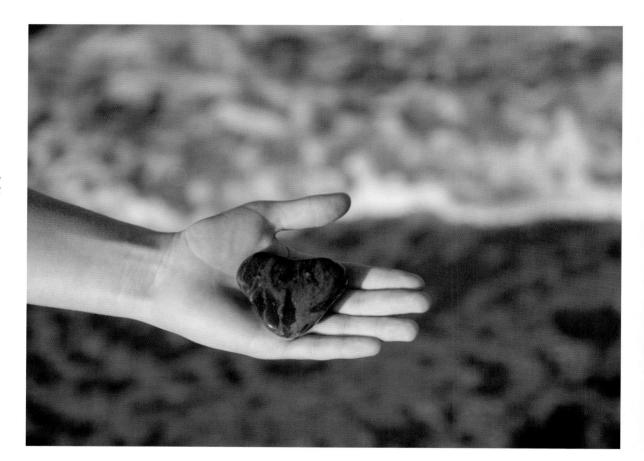

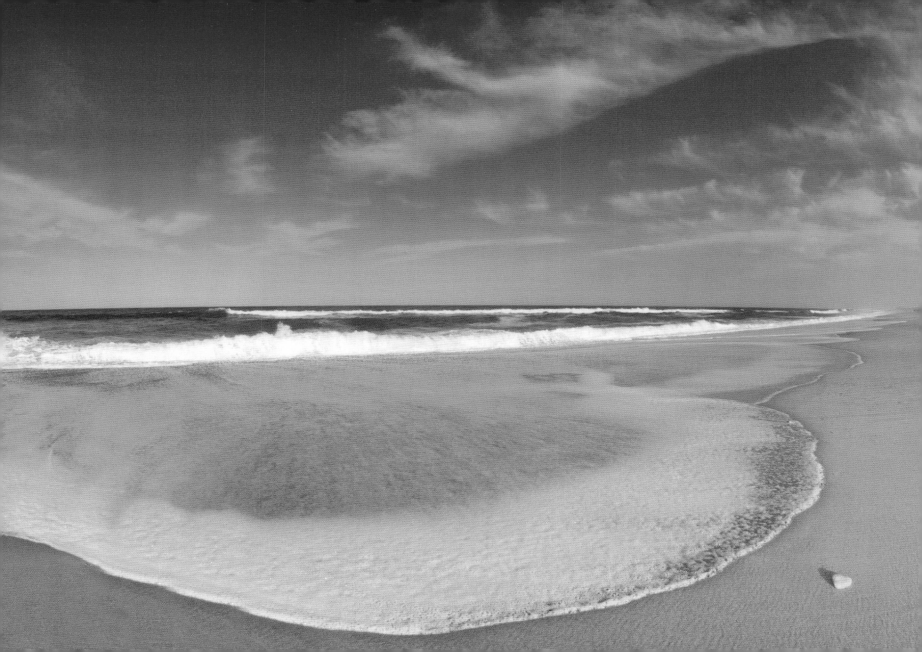

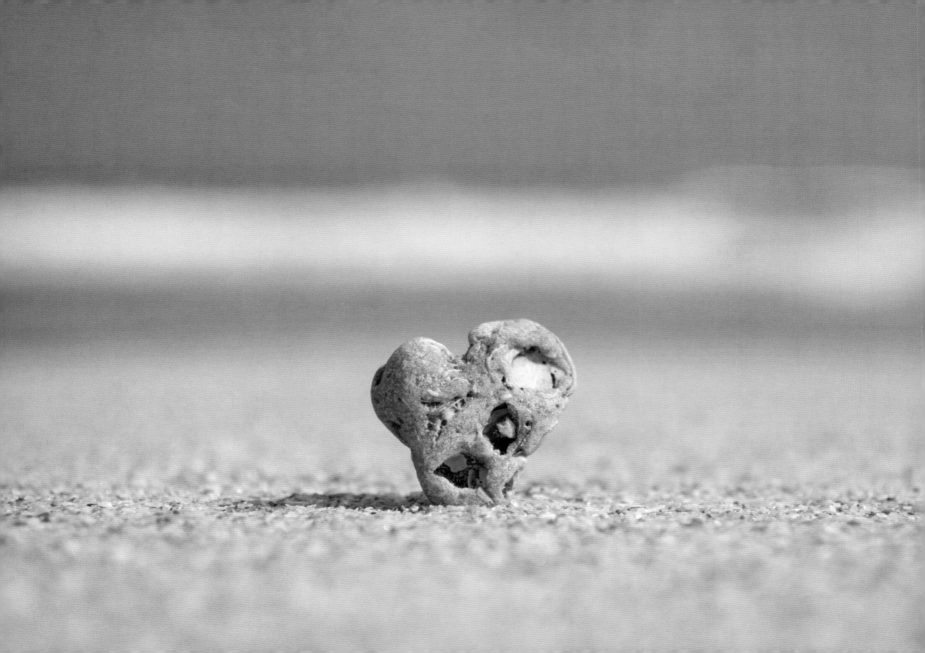

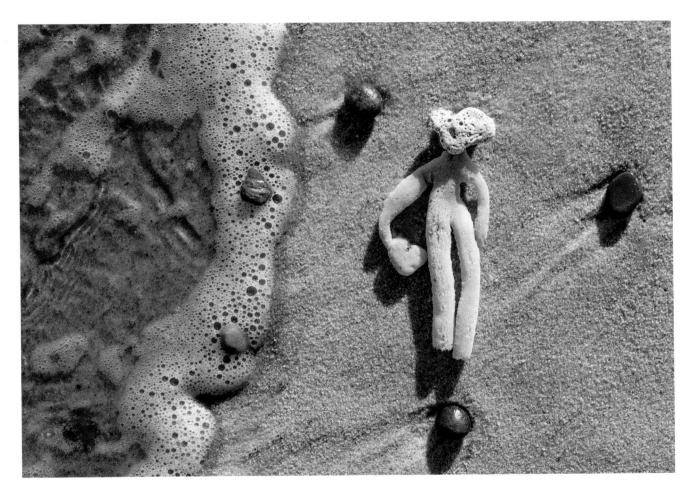

Kangaroo

This heart shelters a tiny heart inside, a baby protected in its pouch. What more can any of us do?

Spongebather

Sponge Bob here found me on Nauset Beach, heart in hand awaiting the next big wave.

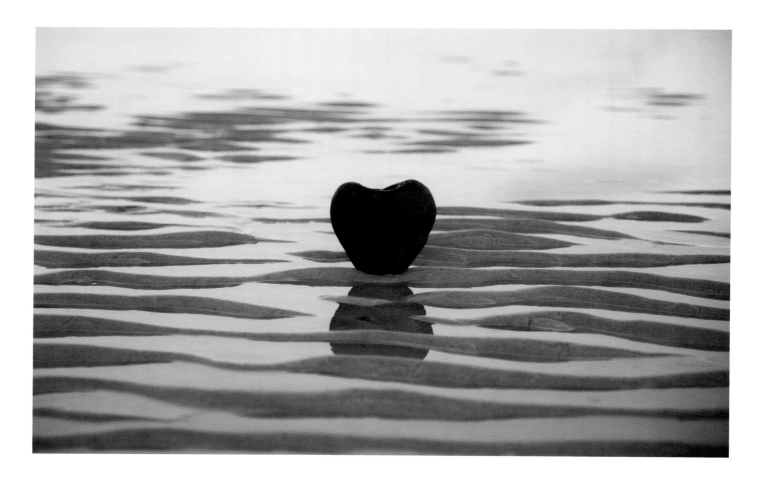

Ripple Effect

The outgoing tide leaves behind beautiful undulating patterns in the sand. I have always loved these ripples, accented and defined by the intervening seawater inlets. This heart and its reflection are definitely in the right place at low tide in Cape Cod Bay.

Storm Surf

A heart can create calm during the storm. This heart found me, accompanied by a dear friend, and made my heart stand still despite the surrounding tumult.

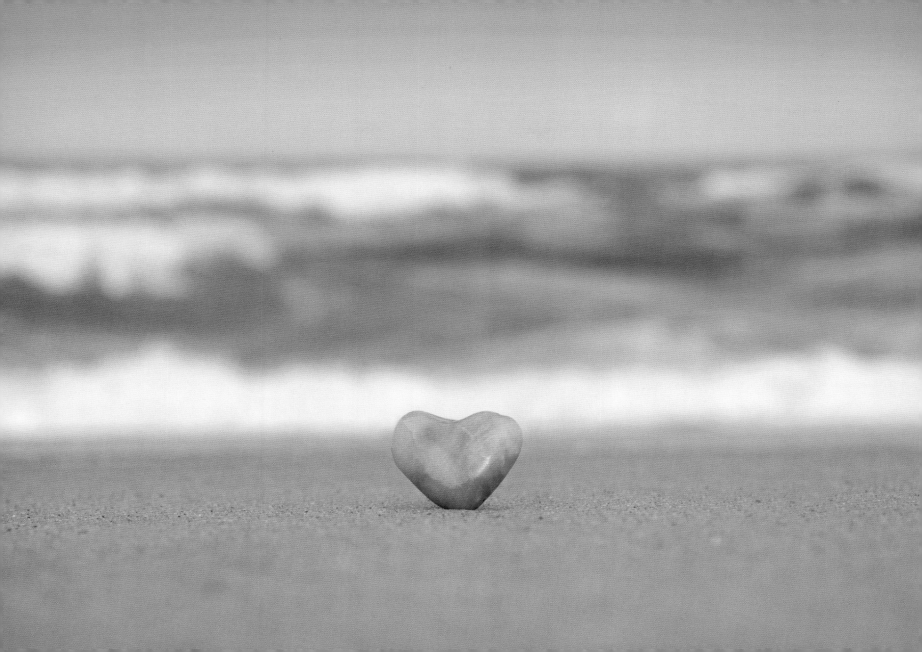

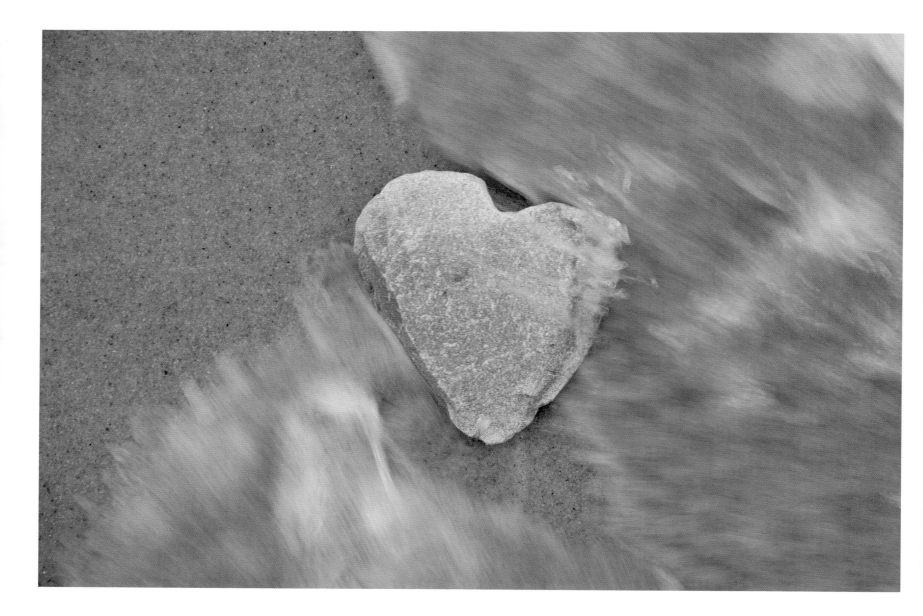

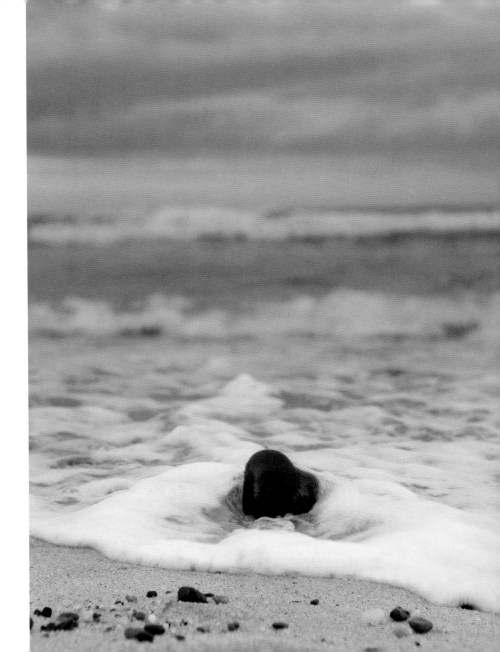

Change of Heart

This dry beach heart is about to be transformed by the touch of an incoming wave, just as it has for countless years before it found me.

Sinking Heart

This heart tumbled on a stormy evening, clouds building and rain approaching but held at bay long enough for me to catch the waves being parted by a small stone.

Yin Yang

As I was photographing a sea of gray-colored stones in Nova Scotia, I noticed a bit of white between two rocks. I rifled through the rocks and removed the white stone, only to discover a lovely dark heart on it. Even better, it also had a white heart which, upside down, helps create the dark heart. The yin-yang heart, two hearts—opposing but complementary.

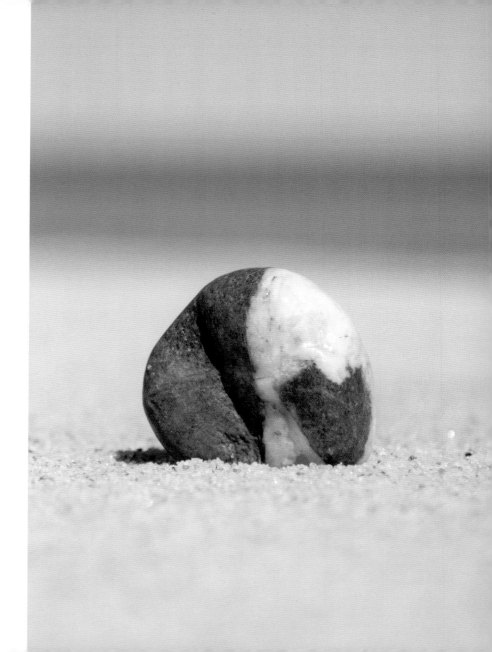

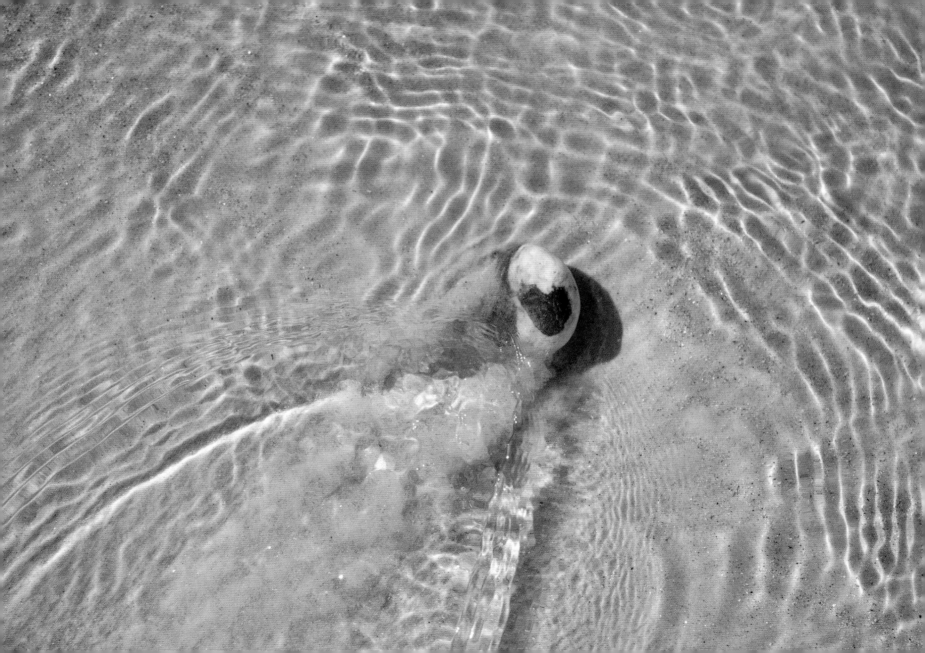

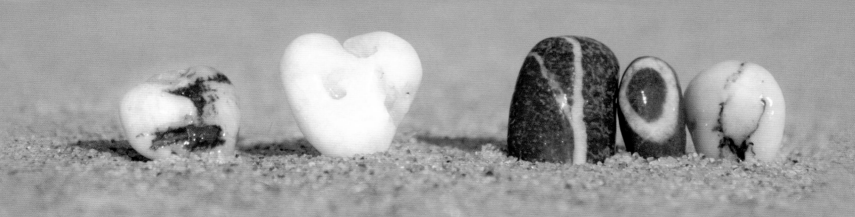

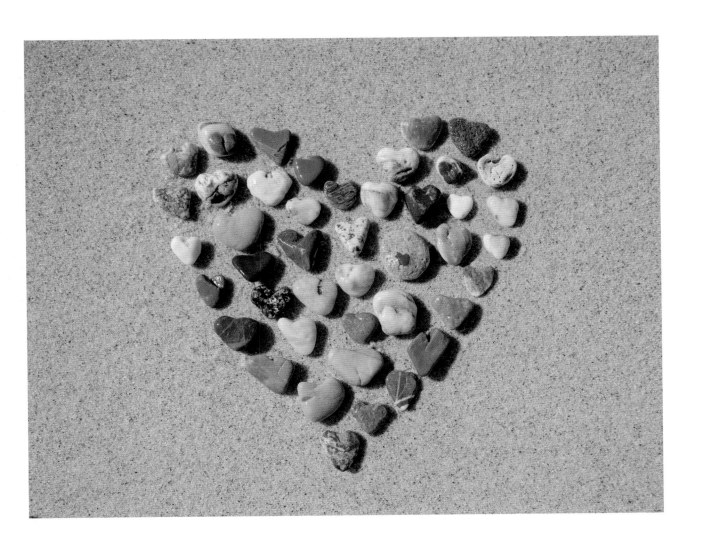

I Heart You

Love you, Cape Cod, for your
unfailing generosity.

Soon, the Next High Tide

At the end of the day when the sun is low in the sky, the surf's foam beams a brilliant white against the sand, and the rocks have been delivered. The simultaneous deaths of the wave and the day seems quietly symmetrical and natural. Destined to repeat endlessly, awaiting my visit tomorrow.

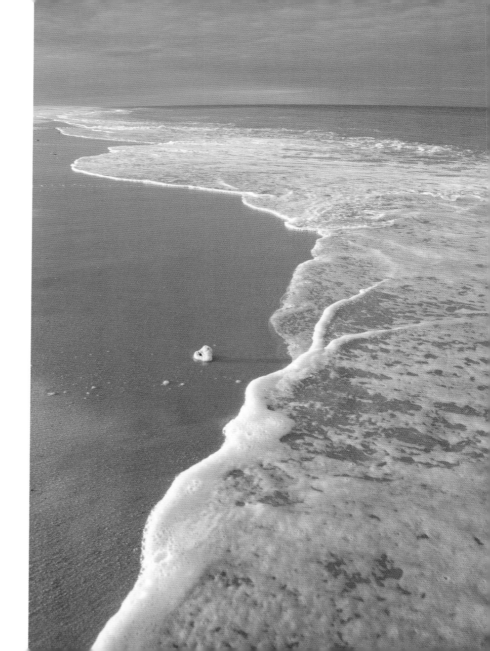

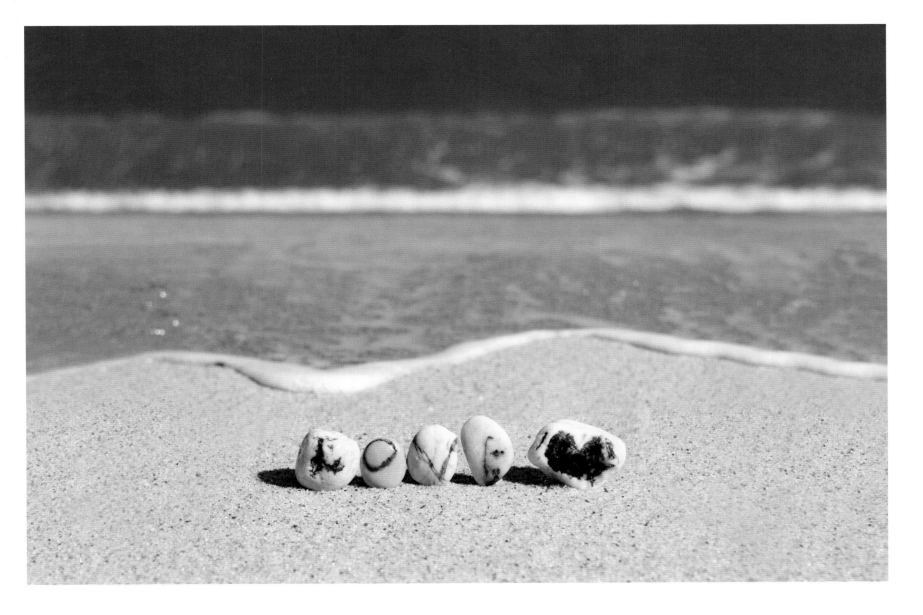

AFTERWORD

Finding the Place of the Heart

Greg O'Brien

Rocks have always held a place in my heart, ever since I was a young boy vacationing on Cape Cod. Leaving the Cape at the end of summer was always a sad experience for me. I can remember the empty feelings as I filled my duffel bag—the sneakers with the holes in the tips, my jeans with sand in the pockets, a surfing jam bleached by the sun, my wrinkled baseball cap—and carted it out to the station wagon. It always seemed to rain that day.

About a half-hour before the family was ready to leave, all ten of us, I would take one final walk from the cottage off Herring Brook Road in Eastham to nearby Thumpertown Beach on Cape Cod Bay. Along the way, I'd relive the summer—days fishing on Salt Pond, the time we hiked to the Old Coast Guard station, the bicycle rides along the back roads to Orleans, the soothing pounding of the ocean, the sweet smell of beach plums. Each memory was precious as time was slipping away

When I reached the bluffs of the beach, I paused for one last look with the hope that I could freeze the moment in my mind. I then walked down the wooden steps to the beach—each of the thirty-two planks creaking from summer wear and tear; the gray paint peeling back; many

of the nails rusted from the sea air. I could see the charred remains of Labor Day campfires that had blazed the night before. Once on the beach, I ceremoniously walked, as I did each year, to the surf.

There is something about a Cape Cod summer that no other summer place can match: The sky is brighter, the sun more radiant, the sand softer, the air more pure, the mood more peaceful. Like many before me, I sought some tangible connection to this fragile, narrow sliver of land—something, a part of me, which I could leave behind. And so each year at this time, I would walk the beach looking for a special rock, a memory to file deep within. It had to be perfect in every detail—symmetric, polished, and about the size of my fist. It had to have just the right feel. It had to feel a part of me.

I usually picked up about three dozen rocks, most of them heart shapes, until I found the right one—my selected memory of that Cape Cod summer. The rejects were tossed into the bay for more polishing. I then walked back to the staircase and buried my treasure about twelve inches from the foot of the stairs.

All winter long in New York, I'd think of my rock; the summer memories it conjured up helped me through the dreary days.

Then each summer when we returned to the Cape, the first thing I'd do, after unpacking the duffle bag, was to race to the beach to retrieve the rock. I always found it, of course. I had convinced myself—and tried to persuade my mother—that any rock of similar size was the one I had stored. I collected these rocks in the backyard of the cottage we always rented, walking over them barefoot at times like a cobblestone path to a paradise.

I'd like to think they're still there.

Amy has taught me that as memory fades, the heart rocks....

Greg O'Brien is the author of On Pluto: Inside the Mind of Alzheimer's, O'Brien's Original Guide to Cape Cod & the Islands; A Guide to Nature on Cape Cod & the Islands.

"Amy has taught me that as memory fades, the heart rocks..."

Acknowledgments

Generous thanks to Peter Schiffer for appreciating the generosity implicit in my work, in these rocks, and their images and to Schiffer editors Catherine Mallette and Dinah Roseberry. Many thanks to book designer Brenda McCallum.

Thanks also to my sons, Charlie and James Kiernan, for living with me when I literally had rocks in my head. I could never adequately thank my sisters: Elisabeth Dykens, for her lifelong support, for believing in this book project from day one, and for being my kindred spirit and beachcombing soulmate; and Nancy O'Neil for her lifelong daily love and support. Very special thanks to my brother Jim for helping me translate what I wanted my images to convey into words, and to my brother-in-law Robert Hodapp, for excellent guidance and editing; I cannot thank you enough. Special thanks to Katie McConnell for her friendship, positivity, and support and to Douglas Karlson, for our many conversations about our diverse book projects and for his encouragement. I am forever grateful to Lisa Bacon for sharing both her rock collection and her enthusiasm, and to my tribe of rockhounds and rock handlers who so willingly gave me their beautiful finds, a generosity of spirit cherished many times over.

Thank you to Greg O'Brien, Timothy Shriver, Lisa Genova, Jim Walczak, Charles Fields, and Joanne Doggart, for giving me their time and advice. Thanks to my loving friends and family who have encouraged me (then and now) and have given me much inspiration: Bob Lassiter, Julie Dykens, Joanne Bergquist, Sean O'Neil, Mike Kiernan, Virginia Osborn, Charles Bell.

Special thanks to the many friends who have supported and encouraged me with my photography over the years, I am so very grateful for all of you—most especially Kalson Pang, Amy Farrell, Rene Votteler, Paul Critikos, Shelly Hippler-Conway, Karen Rood, Danny Walsh, Patrice Milley, Steve Sedman, Diane Marshall, Susan Crowley, and Patricia Parker.

Finally, an obviously heartfelt thanks to my parents: James Dykens, who instilled in us the wonder of art at a very young age as well as the encouragement to think outside of the box; and Thelma Dykens, who has supported my art since I was a child gluing rocks together and painting them at the picnic table, and who supports it still as shown by her enthusiasm for heart rocks, one of which she carries in her handbag at age ninety—a precious gift of remembrance.

Appendix

The wonderful added benefit of photographing rocks is that they can be enjoyed, photographed, and then left on the beach where they originated. Although I have some of my favorites cluttering my desk or bedside, I also enjoy the stones exactly where they are discovered. I borrow them from mother nature, eventually to be returned to where they were found after they are lovingly photographed.

Many of my heart rock images were created at Nauset Beach, Orleans, Cape Cod, Massachusetts. Some of the other Cape Cod locations are Skaket Beach, Orleans; Pleasant Bay, Chatham; Jacknife Cove, Harwich; Lieutenant Island, Wellfleet; Cahoon Hollow, Wellfleet; Point of Rocks, Brewster; and Paines Creek Beach, Brewster. Nova Scotia sites include Carter's Island, Port Mouton; Louis Head, Shelburne County; and Little Harbour, Shelburne County. Further afield, heart stones found me at Jekyll Island, Georgia; New Smyrna Beach, Florida; Playa Garza, Costa Rica; Playa Guiones, Nosara, Costa Rica; and Vieques Island, Puerto Rico.

Photo: Charles Kiernan

Photographer Amy M Dykens sees and captures the world in ways that surprise and delight others. Bringing her extensive background in the arts to the camera, Amy creates sensitive, artistic, and timeless photographs. She has a degree in art from Smith College and, as an artist, photographer, and furniture maker, has been represented in galleries and collections nationwide and has been honored with many one-woman shows and awards. She specializes in wedding photography, portraits of children and newborns, and beach photography. Her images are treasures because they evoke emotion, whether from a newborn yawn, a father's tear on his daughter's wedding day, or a heart stone in the outgoing tide. Amy lives in Cape Cod with her two sons and spends time in Shelburne County Nova Scotia, near the birthplace of her mother.